NEW MATERIALS IN SCULPTURE

NEW MATERIALS
IN SCULPTURE

COLD CASTING IN METALS
GLASS FIBRE, POLYESTER RESINS
VINAMOLD HOT MELT COMPOUNDS
COLD-CURE SILASTOMER FLEXIBLE MOULDS
CAVITYLESS SAND CASTING
VINAGEL

H. M. PERCY

WITH A SECTION ON
CASTING IN CIMENT FONDU
BY

EDWARD FOLKARD, F.R.B.S.

SECOND EDITION REVISED AND ENLARGED

NEW YORK / TRANSATLANTIC ARTS / 1966

Acknowledgments

The section in Chapter 11 (pages 114-117) on making impressions and press moulding with Vinagel, is based on the pioneer work carried out by the Department of Western Asiatic Antiquities, British Museum. The author gratefully acknowledges the assistance given by Dr. R. D. Barnett, Keeper, and Mr. C. A. Bateman, Senior Museum Assistant, for the support given in compiling this section, and for plate 76. Acknowledgments are also due to the following: Messrs. Holt Products Ltd. (illustrations 2-7, 10-13, 16-19); Vinatex Ltd. (45-47, 50, 51, 54, 56-60); Franta Belsky, FRBS, ARCA (23, 30, 31); F. I. Kormis (22); Miss Kathleen Parbury, ARBS (25, 26); Herbert Dacker (36), Anthony Gray, ARBS (32, 33, 35, 38); H. S. Atkinson (75); The Sculptor (39); Kenneth Stanley, Managing Director of Metal Ventures Ltd, for his help and plate 14; D. A. J. Patterson, Managing Director of Metalaids Ltd. who are the exclusive licensees of Professor Wittmoser and Grunzweig and Hartmann for cavityless casting (77); Lewen Tugwell (27, 34); Roger Leigh (28); Alex C. Schwab (29); Mrs. Tatania Pomus Alving (37); Clark & Fenn (45); Midland Silicones Ltd. (61-72); Pytram Ltd. (61, 62, 65-72); A. P. Films Ltd. (65 & 66); Courage and Barclay Ltd. (67-71); Mrs. Mary Catterall (73, 74); Engineering Industries Journal (78-80); William Mitchell, DesRCA. AIBD, and William Mitchell Associates (24 and front cover).

Thanks are also due to the following for their technical assistance and guidance: G. & R. Dunton, E. Bainbridge-Copnall, MBE, for Chapter 5 and plate 39; C. A. Wills of Vinatex Ltd.; Lafarge Aluminous Cement Co. Ltd. (and for plate 85); Mr. Peter Smith for reading the chapters on glass fibre and polyester resin; and lastly, thanks go to Edward Folkard, FRBS, for writing the chapter on casting in cement fondu (and illustrations 81-99), and to John Tiranti, FRSA, for his unfailing help.

FIRST EDITION 1962

SECOND EDITION, REVISED AND ENLARGED 1965

First American Edition:
Transatlantic Arts Inc.
565 *Fifth Avenue,*
New York, NY 10017

PRINTED BY LAKEMAN & CO., LTD., LONDON, W.C.1.
BOUND BY MANSELL BOOKBINDERS LTD., LONDON, N.1.

Contents

List of Suppliers in Gt. Britain

Cold-Cure Silastomer
MIDLAND SILICONES LTD.: Barry, Glamorganshire (for large amounts)
TIRANTI: 72 Charlotte Street, London W.1. (small amounts)

Expanded Polystyrene
METALAIDS LIMITED: Camp Hill Avenue, Worcester

Polyester Resins, Glass Fibre
TIRANTI: 72 Charlotte Street, London W.1.

Scopas Metal Fillers
TIRANTI: 72 Charlotte Street, London W.1.

Ancillary Materials and Tools for Laminating
TIRANTI: 72 Charlotte Street, London W.1.

Vinamolds, Vinagels
TIRANTI: 72 Charlotte Street, London W.1. (amounts under 1 cwt)
VINATEX LIMITED: Devonshire Road, Carshalton, Surrey (amounts over 1 cwt)

Ciment Fondu
TIRANTI: 72 Charlotte Street, London W.1.

Bibliography

HUXLEY-JONES, Modelled Portrait Heads
LEWIS & WARRING, Glass Fibre for Amateurs
MILLS, Sculpture in Ciment Fondu
MORGAN, Glass Reinforced Plastics
NEWMAN, Plastics as an Art Form
PARLANTI, Casting a Torso in Bronze
POUTNEY, Modelling a Figure in Clay
TOFT, Modelling and Sculpture
WAGER, Plaster Casting for the Student Sculptor
ZANIBONI, Anatomical Man: Bones and Muscles for the Art
 Student.

Preface to First Edition

FOR VERY MANY YEARS, the materials and techniques used in sculpture have changed very little. Since World War II, however, new materials have almost literally poured out of the research laboratories of the world—and some of them could be of great advantage to the sculptor, if he is so minded.

Science has made vast strides in recent decades, and industry has not been slow to adopt many of its discoveries. Firms engaged in production, have every right to be resistant to changing from old to new materials and techniques, for they just cannot afford to take chances. Where they have adopted new materials, such as glass fibre reinforced polyester resins and the vinyls, it is a direct endorsement that these have been proved.

The manufacturers of such materials are interested primarily in large volume sales, and are therefore mainly concerned in introducing and selling their products to big industrial users rather than to individuals. It is for this reason that the sculpturing world has hitherto not had the opportunity of finding out about many fascinating materials. A number of these, of direct benefit to the sculptor, are for the first time now being made available.

This book contains details of several new materials and techniques that are revolutionising the whole field of sculpture, for their use is bringing down costs without in any way sacrificing the quality of the result. At present, only the fortunate few can afford to commission a work of sculpture in metal; but if the cost of such a commission, due to the adoption of new materials and techniques, was at least below a quarter of work produced by the traditional way, then many more commissions would be made.

It has been said that the art of true living is to have an open mind—one, therefore, that can accept new ideas, sift them, weigh them, and if found better than the old—then adopt them. The properties of glass fibre reinforced polyester resins offer completely new ways of expression, and unfold new horizons for the sculptor. The range of applications of this new medium seems almost limitless, and new techniques of using it are being found every day.

This book is rather in the nature of a challenge to sculptors to experiment with these new materials, and thus find out what can be done with them. It is encouraging that some of our leading sculptors have already found them of merit—especially the cold cast process.

Preface to Second Edition

This second edition has been completely revised and enlarged. Illustrations (many of them new) showing techniques and materials have been incorporated with the text, and explanations of the technique and modus operandi of Cold Casting in Metal and Glass Fibre work, set out in a more helpful way. New sections have been added on Cold-Cure Silastomer (Silicone Rubber), casting in Ciment Fondu, Matched Die Moulding with Vinamold, and Coreless Casting in the Foundry.

A feature of the book is the section containing the calculating tables for estimating how much Polyester Resin is required for a given area; this section also contains many formulae for finding the surface area and volume of all the basic shapes and forms.

Since the first edition of this book, it has become evident that Cold Cast Metal sculpture is here to stay, and there are many examples to be seen in and on new churches, public and private buildings, galleries and academies. It is of particular interest to note that, at the time of writing, several wall reliefs in Cold Cast Metal have been produced, each covering several thousand square feet, indicating that this casting medium has removed all limits on the size of sculpture.

<div style="text-align:right">

H. M. Percy,
East Grinstead
Spring 1965

</div>

Chapter 1

Glass Fibre Reinforced Polyester Resins: An Introduction to their Qualities and Potentials

Glass fibre reinforced polyester resins are loosely, but incorrectly, called **Fibreglass,** which is the trade name of a manufacturing firm producing glass fibres; they are, in fact, laminates, that is to say alternate layers of resin and glass fibre reinforcement. The qualities of glass fibre laminates are really quite unique, and no special skill is required from the operator, just an understanding of how to proceed. In fact, the process is so simple, that one can proceed virtually with the laminating brush or roller in one hand, and the instruction book in the other. Sculptors will find the techniques extremely easy to master, and they will appreciate the small capital outlay, low labour costs, and versatility of construction. What are the properties of glass fibre laminates? Provided the laminate is correctly made, i.e. the correct admixture of hardener, resin and other ingredients, and the correct room temperature observed during the laminating and curing stages, the result is a dimensionally stable and accurate end product. Glass fibre laminates are as strong as steel, yet only one third of its weight; impact resistance is high, and better than many metals. Resistance to extremes of weather is excellent, and so also is resistance to deformation, cracking or warping—all points of great interest to the sculptor. Laminates have good resistance to heat (up to 250°C), and thermal conductivity is low; they can be drilled, tapped, sanded, buffed, cut and polished, using conventional metal working tools.

Laboratory tests have been made on glass fibre laminates, mild steel, and aluminium. After tests lasting thirty days, at 65°F (20°C), to determine resistance to corrosion and attack, a test panel of laminating resin and chopped strand mat glass fibre, fully cured, completely resisted the following treatment:

Tapwater
20% Sulphuric Acid Solution
20% Hydrochloric Acid Solution
10% Phosphoric Acid Solution
Seawater Immersion

Whereas the mild steel and aluminium panels were attacked in every

case, the aluminium faring worse than the mild steel. It will be seen, then, that glass fibre laminates are more weather resistant than either of these two metals.

The marriage of glass fibre and polyester resin is truly a fruitful one. This may seem rather odd, when it is realised that glass in itself is such a brittle material, and that a block of cured polyester resin is so easy to shatter—yet in combination, these two materials can possess a tensile strength of up to 50,000 lb. per square inch. The reason for this is not far to seek. Plastics, speaking generically (and cured polyester resin is a plastic), lack strength. Glass fibre, on the other hand, possesses enormous tensile strength, yet lacks rigidity: its mechanical strength can only be put to practical use if it can be held in a permanent and rigid shape. These two materials, laminated together, provide the sculptor with a unique medium that can be formed to almost any shape. It will, however, require to be three times the cross sectional area of a piece of steel in order to have the same tensile strength, in which case, it will weigh approximately three fifths of the weight of steel. For the same resistance to bending, the glass fibre laminate will need to be 2.7 times the thickness of the steel, in which case its weight will be approximately half that of steel.

For the sculptor, then, these materials, when allied to metal powders, are a gift from heaven. A metal surfaced cast is so easily produced, and there is no need to employ costly, and time consuming, specialist foundry assistance. Limitations both of size, and form, previously imposed on a sculptor by traditional materials (because of weight or cost), are lifted. Soaring multiform shapes, seemingly unfettered by gravity are now capable of practical achievement, due to the great strength to weight ratio of glass fibre metal surfaced laminates.

This book only goes into detail about the basic materials necessary for sculpture work, although the following chapter gives a general outline of glass fibre laminates, and the reasons why various resins and additives are used. **New Materials in Sculpture** is a complete instruction book in itself on the techniques of hand lay-up of glass fibre reinforced polyester resins, and cold cast metals, and provides that information required by the sculptor and designer, to enable him to work in confidence in quite a new range of new materials, ideally suited to his purpose and art form. The bibliography at the front of this book gives further reading on other aspects of glass fibre laminates.

Chapter 2

*Background to the Materials for Glass Fibre
Reinforced Polyester Resins and
Cold Casting in Metal*

This chapter will provide a background knowledge of the materials and terms used in glass fibre reinforced polyester resin laminating, and in the cold cast metal technique. Those whose knowledge of the subject is little, or hazy, will find it of great help to read this background, before referring to chapters 3 and 4 which give details of operating techniques.

The Resin and Its "Setting" Agents

Polyester resin is supplied as a liquid, rather like a syrup. The resin changes to a solid with the addition of a small percentage of catalyst (also called hardener). Since the hardening, or curing process would normally take a long time, a chemical accelerator is added, enabling the curing time to be controlled at will, from a few minutes to several hours. The

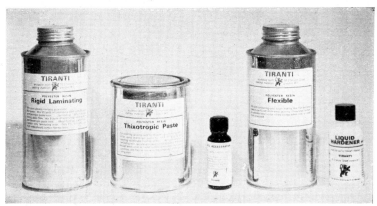

1. The three basic Polyester Resins—Rigid Laminating, Thixotropic Paste and Flexible—together with Liquid Hardener and Accelerator.

laminating resin dealt with in this book is that supplied by Tiranti's, and it already contains a fixed amount of accelerator. This resin has been specially formulated for use in sculpture, and no further accelerator is normally required.

Gel Time, Pot Life, and Cure Time

When the required amount of catalyst has been added to the resin, and

3

thoroughly mixed in, the resin starts to **polymerize.** This chemical reaction produces heat within the mix known as **exotherm,** and the liquid changes first into a jelly, then into a soft rubbery substance, and finally it rapidly hardens into an unyielding solid. The time taken by the catalysed resin mixture to turn from a liquid to a jelly, is known as the **gel** time. The gel time varies, according to conditions, and is longer when the mix is spread out on a laminate, than when it is in volume in the mixing pot. It must be realised that the workable, and therefore useful, time of the catalysed resin mixture is that in the pot, and is known as the **pot life** of the resin. Once the resin has gelled, it is no longer usable. The ideal temperature for laminating is 67°F, which is accepted as being average room temperature. Below this temperature, gel times will be extended, and above it they will be speeded up. If resins are used at too low a temperature (below 50°F), there is the danger that the resin will not set at all, without special additives. Although resin cures in a short period, the dimensional stability of the completed laminate is only achieved after several hours, and the full mechanical strength is not reached for fourteen days. However, laminates may be removed from the mould as soon as they are hard.

Composition of a Laminate

What is a laminate ? It is something consisting of layers. In this case, it is layers of polyester resin and glass fibre. Normally, a laminate consists of a first layer of neat resin, called **gel coat,** and then two or more layers of glass fibre, impregnated with more resin. The gel coat, being the first layer in the mould, will be the outside of the finished laminate, and it often contains pigments or fillers for effect or economy.

Thixotropic Resin

When we start to laminate, we begin with the gel coat, which is painted onto the mould surface and allowed to gel. However, since the mould surfaces are very often inclined, or even vertical, something is needed to hold up the resin, while it is curing. We therefore add a little of another type of polyester resin called **thixotropic paste resin,** a resin which is very viscous, and when mixed with laminating resin, prevents drainage away from inclined surfaces of the mould. Thixotropic paste is also added to laminating resin when actually impregnating glass fibre, although not so much is used for this purpose.

Flexible Resin

There are certain special cases when a third resin is required. If a solid

4

block of resin were to be cast, or a hollow object filled, when the laminating resin started to gel, and develop its exotherm, there would be so much stress from the expansion caused by the heat, that the whole thing would deform and so crack and split. To overcome this, a **flexible polyester resin** is added to the laminating resin; this will impart some degree of flexibility to the block (although the cured block will, of course, be rock hard), and so absorb the stresses and strains. The only other time flexible resin is used, is when a thin flat laminate, a panel or sheet, without modelling or ribs, is being made and a certain degree of flexibility is required. Flexible resin, however, is **never** used by itself. It should be noted that the use of flexible resin tends to reduce weather resistance outdoors.

Pigment and Pastes

We mentioned earlier that gel coats often contain fillers, and, or, pigments for effect or economy. **Pigments** are available as specially prepared concentrated colour pastes, ready for mixing with polyester resin. They are generally known as polyester pigments, and some thirty colours are available. It is possible, in fact, to mix any powder colour into polyester resin, but it requires special equipment to produce effective results. Some colours have an inhibiting effect on the resin, and nearly all powder colours are very difficult to disperse evenly and thoroughly. It is, therefore, advisable to use the pastes, which are prepared by experienced artists' colourmen; they are made for the job, and are always compatible with the resin, and in addition are fast to light.

Inert Fillers

As far as fillers are concerned, theoretically almost anything may be mixed into the resin, provided it is chemically inert and dry. Fillers are used for a variety of reasons. Sometimes they are mixed into resin for economy; they make the resin go further, and thus reduce the overall cost—the filler being much cheaper than the resin. They also improve surface hardness. Fillers are, in addition, used to improve opacity in resin where pigments are being used. Again, in practice it is best to use the inert fillers made specially for resin, rather than any powder that comes to hand. Although materials such as plaster, are cheaper than the the prepared fillers, they are difficult to mix, and what is more important, will not improve the surface hardness of the resin as will the prepared fillers.

5

Scopas Metal Fillers

A special class of fillers should be mentioned at this stage, and also **Cold Casting in Metal.** Scopas Metal Fillers are a series of seven metal powders, made of pure metal, atomised to particles of 200 and 300 mesh. These metal fillers are used in the gel coat of laminates in the Cold Cast Metal process, to produce laminates with a metallic surface. The seven powders available are brass, bronze, copper, lead, aluminium, nickel silver, and iron. Metal filler is mixed into the gel coat resin, and painted or poured into the mould; the gel coat is then backed up in the usual way with glass fibre. The cold cast metal technique is really no different from ordinary glass fibre laminate work, except when applied to sculpture. It is then that the special casting techniques normally used in sculpture, are applied to laminating techniques.

Correct Laminating Conditions

Briefly mentioned earlier was the importance of the right temperature conditions. These are vital, if good results are to be achieved. Room temperatures of $65°F$ to $68°F$ are the ideal, and temperatures of $60°F$ to $65°F$ are satisfactory. Below these temperatures, which are considered to be average room temperatures, the gel times will be greatly extended and this is not desirable. It is useful to know that the cross linking agent in polyester resin is styrene monomer, a very volatile substance. If the cure time is too long (several hours), then the vital styrene on the surface will evaporate, and so cause a surface undercure, which shows in the form of tackiness. Very extended cures could result in very inferior mechanical strength, or even result in partially cured laminates that are virtually useless. Apart from cold room temperature, cold draughts and dampness—either in the air, or in the glass fibre reinforcement, due to bad storage—certain fillers and colours, will also produce extended cures. All these difficulties are avoidable by quite simply following instructions. Perhaps it would be best to point out **now** the wisdom of always making a trial mix before carrying out the final work; such caution is amply repaid, for it enables those small adjustments to be made that materially aid in the perfection of the main work. Indeed, it is no exaggeration to say that this simple precaution insures against failure, waste of time and materials.

Polyester Resins

So far, three basic resins have been mentioned; **laminating** resin, which is the basic resin, **thixotropic paste** resin and **flexible**

resin. There are other types of resin, which are modifications of these three, made for special purposes such as clarity, fire resistance, chemical resistance, fast curing, etc. However, such resins do not come within the scope of this book, since they are **not** normally used in sculpture.

Glass Fibre Reinforcement

Very little mention has been made, so far, of glass fibre reinforcement. There are five basic types dealt with in this book. What are the properties of glass fibres, and which type is used for what purpose? It is necessary to understand that glass, drawn into filaments, is very different to glass used in a window. One strand of glass fibre is made up of, perhaps, 200 extremely fine hairs, and in this aggregate form possesses strength and flexibility, for in this filament form glass has lost its brittleness. Laboratory tests have indicated that if enough strands are assembled into a rope making a cross section of one square inch, its tensile strength will be nearly one and a half million pounds; this is practically **ten times** greater than steel. In a laminate, combined with polyester resin, the strength of the glass is reduced, because the weaker strength of the resin will, so to speak, average it out. However, the resultant strength is still greater than steel on a strength to weight basis. The five types of glass fibre reinforcement discussed in this book are:

Chopped Strand Mat. Consisting of multi filament glass fibres, approximately two inches long, randomly distributed, and held together

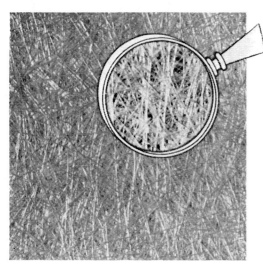

2. Chopped strand mat (photo: Holt Products Ltd.).

7

with a sizing which is soluble in polyester resin. The chopped strand mat dealt with and illustrated in this book weighs 1 oz. per square foot; it is the maid of all work, and is the type of reinforcement most used for sculpture.

Glass Fibre Scrim. A loose weave glass fibre cloth, weighing 5 oz. per square yard, and giving much greater impact strength than chopped

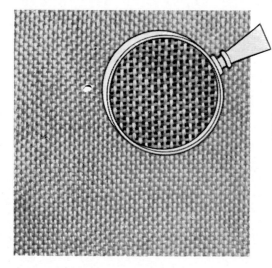

3. Glass fibre scrim (photo: Holt Products Ltd.).

strand mat. Glass scrim is used where high strength to weight ratio is required, or where thin laminates are necessary. The disadvantages of glass scrim are that it has a tendency to de-laminate if not properly impregnated, it is difficult to impregnate with the resin, and lastly, it has a higher cost compared to chopped strand mat.

Glass Fibre Cloth. A tighter and heavier weave than glass scrim, weighing 8 oz. per square yard. The strongest reinforcement of all, but having the same disadvantages as the glass scrim.

Glass Fibre Tissue or Surface Mat. This looks like an extremely fine chopped strand mat. However, it is not used for reinforcement in the normal sense of the word. It is used for finishing the back of a laminate to hide the relatively coarse finish of chopped strand mat, and also it is used to give a resin rich surface without the danger of crazing. Tissue is not used in the cold cast metal process.

Glass Fibre Ribbon. A 2 inch wide ribbon, possessing tremendous strength, and generally used for local strengthening, bonding in fittings, and edging.

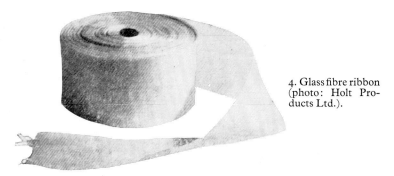

4. Glass fibre ribbon (photo: Holt Products Ltd.).

There are numerous ancillary materials for one special purpose or another, such as barrier creams, paper rope formers, bighead bolts, etc. These are dealt with in the next chapter which deals with laminating.

Chapter 3

Laminating Techniques

It is advisable to repeat that all the materials discussed in this book are those obtainable from Tiranti's. They have been designed, or specially selected, for sculpture work, and have all been proved in experience. If substitutes are used, results similar to those described here may not always be achieved. The use of other polyester resins and catalysts is, of course, possible, but **tests must be made first** to determine suitability, since there are many curing systems and resins which will result in failure when used with metal fillers, or for sculptural purposes. One further cautionary word: the sequence that follows is for purposes of clarification, and not necessarily the sequence for working. The various sections under this chapter are:

Section A—**Mixing of Components** (gel coats, mixes, pigments, etc.)
Section B—**Release Agents**
Section C—**How to Laminate**
Section D—**Reinforcement Techniques and Bonded in Fittings**
Section E—**Tools and Ancillary Materials**
Section F—**Cleaning Tools, etc.**
Section G—**Resin Calculating Tables and Useful Measuring Data**

SECTION A—Mixing of Components

Insufficient mixing causes waste and delay. Thorough mixing of components is, therefore, extremely important, because if badly carried out, uncured, or partially cured laminates will result, which must be scrapped. Where metal fillers are being used, then it is even more important to ensure that all components are thoroughly mixed.
As has already been explained, polyester resin starts to set as soon as catalyst (hardener) has been added. Once added, then nothing can prevent setting. This means that all preparations must be made, and everything checked before mixing in the hardener. Have the treated mould ready, and all tools to hand before adding catalyst to the gel coat mix, and have the glass fibre cut to size, the rollers and brushes to hand before adding the catalyst to the laminating mixture. The setting

time of all mixes is shortened when additional accelerator is put in; remember that liquid hardener and liquid accelerator should **never** be mixed directly together, and that one should always be well mixed into the resin before the addition of the other. It is preferable to add accelerator to the mixture first, and then the hardener. Resin mixes, broadly speaking, are made up for two purposes—gel coats, and laminating.

Gel Coats

Depending on its purpose, a gel coat can consist of a number of components; several are given below, together with the proportions by weight.

Simple Gel Coat 85 parts laminating resin
15 parts thixotropic paste resin.

Accelerator is already incorporated in the laminating resin, so an additional amount is not necessary. Using the calculating tables at the end of the chapter, make up the total amount of gel coat mixture required for the whole job. Bearing in mind that 1% of hardener will give a pot life of approximately 28 minutes at normal room temperature, measure off the amount of gel coat mixture you think you can use up in this time, and mix in the hardener. Calibrated paper cups are available for measuring out polyester resin without the bother of using scales; the cups are printed inside with a scale showing resin ounces (see plate 20). The hardener bottles are graduated, and also have a fitting in the neck to measure out drops accurately. Full instructions for the use of hardener are printed on the bottle: briefly, 1% of 1 lb. is one calibration on the bottle. For smaller quantities, the 1% of 1 lb. is exactly 100 drops, and pro-rata, so that 6 drops of hardener are used for each ounce measure of polyester resin.

Note that the amount of hardener used is calculated on the **total** amount of resin used, i.e. both laminating resin and thixotropic paste resin together, but **not** including the weight of any fillers. Although the pot life of the mix is 28 minutes approximately, it must be appreciated that the gel time of the resin mix when spread out on the mould is considerably more than this; no exact time can be given, because room temperature will make a tremendous difference, but between 45 and 90 minutes is about average.

Mixing Thixotropic Paste

When mixing thixotropic paste with laminating resin, the following

method should be adopted. Measure out the required quantities of the two resins; pour a quantity of laminating resin, equal in volume to all of the thixotropic paste resin, into the mixing pot, and add the thixotropic paste. Mix thoroughly until evenly blended. Then gradually add the rest of the laminating resin, stirring thoroughly all the time. Do **not** add the thixotropic paste to the total amount of laminating resin; if you do, the result will be a resin mix with islands of unblended thixotropic paste floating around, and mix how you will, these islands will remain.

Accelerator and Hardener
Should a faster setting time be required, do not add more hardener, but blend additional liquid accelerator into the mix. Normally, a further 1% should be sufficient. A word of caution here: additional accelerator will cause rapid curing by speeding up development of the exotherm. This means that the resin in the mould will become very hot, and thus expand; on cooling, it will shrink, and possibly warp. The only time further liquid hardener is added to the mix, is when Scopas metal fillers are being used in the gel coat; in this case, between 2% and 4% should be used, to overcome the retarding effect of the metal.

Resilient Gel Coats
When completely flat laminates are required, which will have to flex slightly, then the following mixture should be used (parts by weight):

Resilient Gel Coat 75 parts laminating resin
15 parts thixotropic paste resin
10 parts flexible resin

In normal sculpture work, this type of gel coat is rarely used; it should certainly not be used when metal fillers are being mixed into the resin to give a metallic surface.

Pigmented Gel Coats
Either of the above gel coat mixes may be coloured with pigments. It is important to note that no more than 5% by weight, of the total resin mix, should be used of the pigment. As with thixotropic paste mixing, weigh out the required quantities of pigment and gel coat mixture. It is convenient here to weigh out the required amount of pigment in the mixing bowl. Add to the pigment an approximately equal part (by volume) of the gel coat mix, and blend the two together. Now add the rest of the gel coat mix stirring thoroughly all the time. Since pigments

have a retarding effect on the gel time of polyester resins, and this must be compensated for, add 1% accelerator to the gel coat mix before mixing with the pigment. Two or more colour pigments can be mixed together to obtain any desired shade, but care must be taken that the 5% limit is not exceeded.

It is essential that the pigment paste is weighed out accurately. Since these pigments are highly concentrated, even a slight variation in quantity will result in variation in shade. It is important, therefore, to mix up the total amount of pigmented gel coat required for a particular job, **at one time.** Small quantities of resin, up to 5 lb. can be mixed by hand. Larger quantities will require the use of a power driven mixer. When drawing off small amounts from your stock of pigmented gel coat mixture, stir well beforehand, in case any of the pigment has settled. The addition of dry filler powder will improve the opacity and the hardness of the gel coat. There are no fixed or ideal proportions of filler to resin, and small tests should be made to find out the best proportion for the job in hand, and the colour being used; a rough guide is $\frac{1}{2}\%$ to 1% by **weight.**

Laminating Mix
There is only one basic laminating mixture: (by weight)

> **Laminating Mix** 9 parts laminating resin
> 1 part thixotropic paste resin

This mixture, with hardener added, is painted onto the firmly cured gel coat, and glass fibre put on top; the resin is then worked through the glass fibre by means of rollers or brushes. The technique is described later on. When pigment has been used in the gel coat, it is normal practice to use the same amount in the laminating mixture. It should be noted that flexible resin is **never** used in laminating mixtures. The above laminating mixture is available, ready mixed and accelerated, as Tiranti's laminating resin Type B.

SECTION B—Release Agents

Most moulds require a parting agent, exceptions being some rubbers, Vinamold, and Silicone Rubbers. There are several parting agents, each designed to give easy release for specific jobs.

13

Bellseal

A water soluble, film forming fluid, developed for the special demands of the sculptor: moulds with great detail, and many undercuts, are easily treated. Bellseal is a most efficient parting agent for polyester resin but it should only be used on waste moulds, or where one off is required, because it has to be applied each time a cast is taken. The mould should be thoroughly dried out, particularly plaster moulds, and one good coat of Bellseal applied to the mould surface. It should then be allowed to dry out thoroughly, before the gel coat is painted over its surface. A word of caution here: Bellseal is water based, and will therefore continue to dry out until the resin is put into the mould. For this reason, it is not advisable to leave the film to dry out longer than overnight. If left for a longer period, it will tend to dry out too much, thus shrinking, stretching, and finally peeling off. If drying Bellseal artificially, take care not to overdry. When the cast has been made, and removed from the mould, any Bellseal remaining on the cast may be removed with hot water and a stiff brush. Should the Bellseal in the bottle become too thick to use, it may be diluted with distilled water.

Emulsion Wax Release Agent

A quick drying emulsion of hard drying synthetic wax. Best applied with a lint free rag using firm pressure to obtain a continuous film. Should the compound have thickened during storage, then just sufficient water should be added to make application and spreading easier. If ridges appear at the end of each stroke during application, either too much has been applied, or a little more dilution is needed. Do not, however, add more than 1 part of water to 2 parts emulsion wax.

Blue P.V.A. Release Agent

A quick drying solution of polyvinyl alcohol in water and organic solvent. Whilst best application is achieved by spraying at a pressure of 40 lb. per square inch, it can be applied most effectively by sponge or soft brush. Ordinary paint brushes will cause "tramlines" which may remain on the mould surface, and therefore be reproduced on the final laminate. Always keep the bottle well stoppered to prevent evaporation of the organic solvents.

Wax Polishes

A number of car wax polishes, such as Johnson's, Simoniz, etc., are suitable, but they must be free from Silicones. The wax should be

sparingly applied with a soft cloth, and left for five minutes or so before lightly buffing to a smooth continuous glossy surface. Excessive applications of wax polish can cause sticking, and also wax tends to build up on the mould. In general, waxes should only be used on smooth and flat surfaces without much detail. Never use wax polish which contains silicone in any form, since a reaction may take place with the gel coat, adversely affecting the cure.

Recommended Techniques of Using Parting Agents

A. Bellseal
Used only by itself, and not in combination with any other parting agent. Used mainly for sculpture, and where only one off is required.

B1. Emulsion Wax Followed by P.V.A. or
B2. Wax Polish Followed by P.V.A.
These systems are particularly suitable in the production of mouldings which are then painted. The P.V.A. film comes away with the mould, and is easily removed afterwards with the help of warm water. The mould may then be re-painted with P.V.A. ready for the next cast. Excellent surfaces are obtained, provided care is taken to avoid "tramlines".

C. Emulsion Wax Followed by Wax Polish
This system usually gives a slightly easier release than either of the B systems, particularly if heat is employed in the cure of the moulding. If more than one moulding is required from the same mould, it will be found that this system improves release with each successive moulding.

D. Emulsion Wax Followed by Wax Polish Followed by P.V A.
For certain applications, where best possible release is required, a triple system such as this, may justify the extra cost and effort involved. Such applications include master patterns, new moulds, and deep draw moulds with little or no taper.

Warning. It is not recommended that other combinations are used than the ones described above, because of the possibility of the second layer disrupting the first.

The previous section has dealt with the various mixes and has gone into sufficient detail to equip the reader with adequate background knowledge for laminating. This section describes in detail, with the aid of photographs (plates 5-11), the various stages of laminating up to the final easing of the laminate from the mould. In order to avoid the need for referring back to check the composition of the mixes, the proportions will be repeated in the text, where appropriate. The use of metal fillers is not dealt with in this chapter, nor the special casting techniques for sculpture. Since these are a development of the basic laminating techniques, they logically follow in sequence, and are treated in full in chapter four.

In order to estimate the quantities of resin required for certain areas, estimating tables have been included at the end of the chapter (Section G), showing areas covered by gel coat and laminating mixes.

Stage 1—The Prepared Mould

A mould (in this case actually made from glass fibre reinforced polyester resin), taken from the wooden boat hull. The mould could just as easily be made from plaster or other suitable materials. For the treatment of mould surfaces, see Section B of this chapter. In this particular case, the mould has been painted with P.V.A. parting agent.

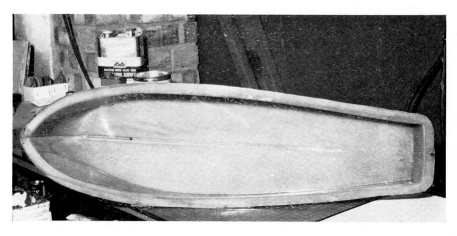

5. The prepared mould. In this example the mould itself is made from resin bonded glass fibre, and has been treated with mould parting agent (photo: Holt Products Ltd.)

Stage 2—Applying the Gel Coat

The gel coat has been made up (85 parts laminating resin, 15 parts thixotropic paste resin, by weight), and the catalyst finally added (1%) and mixed in, only when all preparations had been completed, everything assembled that would be required, and the actual work ready for starting. The mix is shown being applied to the inside surface of the mould: it is painted on fairly generously and evenly. Just under 2 oz. of gel coat mixture should cover 1 square foot of mould area. The gel coat is left to harden, before laminating begins. Otherwise, when the glass fibre reinforcement is applied, it will penetrate the gel coat, and show on the surface of the finished cast. At average room temperature, the gel coat should be ready for laminating in approximately 45-60 minutes. If thixotropic paste resin had not been added to the gel coat, it can readily be seen from this mould that it would run down and collect in a pool at the bottom.

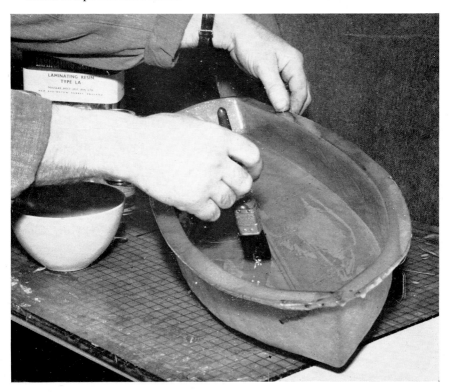

6. The gel coat being painted onto the prepared surface of the mould (photo: Holt Products Ltd.)

Stage 3—Laminating by Brush

Whilst waiting for the gel coat to set, preparations can be made for the laminating stages. Again, note that all preparations should be completed before laminating begins, so that no time is wasted once the catalyst has been blended into the laminating mixture. Remember, the pot life is limited to about 28 minutes, so do not add catalyst to more of the laminating mix than you can use up in that time. Glass fibre should be cut up ready for laying in position, making allowance for a 2 inch

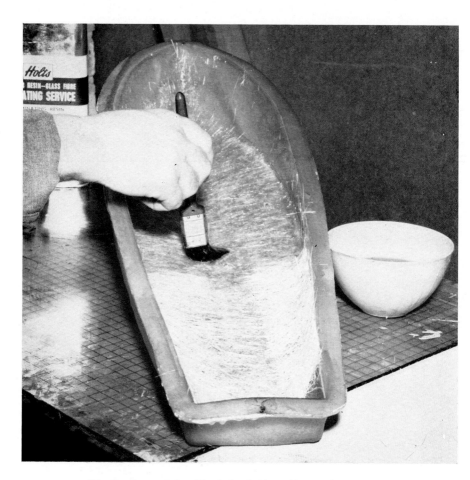

7. The first layer of glass fibre being laminated into position to reinforce the gel coat. The laminating mix is brushed on the solidified gel coat and the glass fibre layer is placed on top. The mix is then forced up through the glass fibre by tamping with a brush (photo: Holt Products Ltd)

18

overlap (more for larger objects) over the mould edge (compare plates 8 and 9). Enough glass fibre should be cut up to laminate the desired

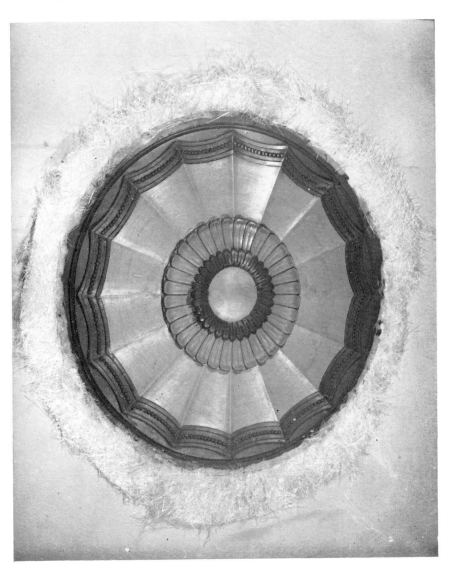

8. A cast of a large ceiling rose, in cold-cast metals made from the Vinamold mould shown on plate 55. The cast has yet to be trimmed; the glass fibre jutting out around the cast is most useful for easing the cast out of the mould. Starting from centre: gold/brass, lead, bronze, aluminium, copper, old silver (photo: A. Tiranti Ltd)

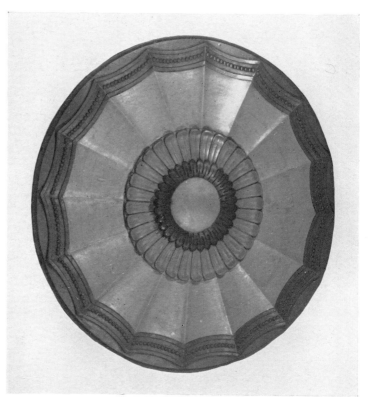

9. The finished cast with edges cleaned off and the surface cleaned up (photo: A. Tiranti Ltd)

number of layers—in this case three layers of 1 oz. per square foot chopped strand mat.

When the gel coat is hard enough, pour out a quantity of laminating mixture (9 parts laminating resin, 1 part thixotropic paste resin), and add the liquid hardener, mixing together thoroughly. The laminating mixture, or 'lay up' mix as it is often called, is applied as a thick coating on top of the now hardened gel coat, followed by the chopped strand mat, previously cut to shape, and which is laid on top. Brushing with a dabbing motion will stipple the mixture through the glass fibre mat, completely impregnating it, and removing all the air bubbles. A "to and fro" brushing action will not give complete impregnation, and will cause the glass fibre to lift and move, probably forming ridges.

It cannot be over-emphasised that all the glass fibre must be completely saturated, and no air bubbles left trapped. It is useful to note that

20

correctly impregnated glass fibre reinforcement becomes transparent, changing from its original white colour. Any silvery or opaque areas will indicate that the glass fibre has not been correctly wetted out; if this is not dealt with now, the result will be a weakened laminate, which in certain cases could separate or delaminate. Three layers of glass fibre mat are being applied in the boat hull illustrated. A third application of laminating mixture was not required, because there was already sufficient surplus from the two previous applications to impregnate the third layer of chopped strand mat. A point to note: an error all to often made it to use too much laminating resin, giving what is termed as a "resin rich" laminate; the aim should be to use only just enough as is required to wet out the glass fibre.

Stage 4—Laminating by Roller

Laminating may be carried out with the aid of rollers, instead of brushes. There are several types of roller to use, and two of these are illustrated in Section E of this chapter. Plate 10 shows a multi-washer roller being used to impregnate the chopped strand mat, squeezing out the air

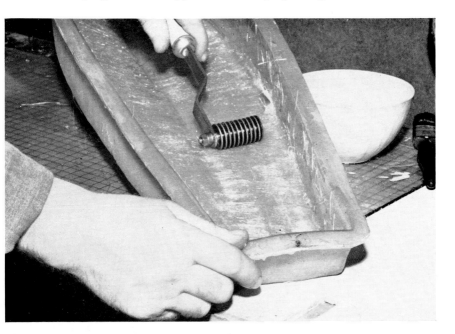

10. The same can be done more quickly and easily by the use of a multi-washer roller as shown here (photo: Holt Products Ltd)

bubbles. The rolling action should be continued until the roller drags on the wet lay up. This indicates complete impregnation and freedom from air bubbles. It is not necessary to exert heavy pressure when using a roller, but a steady even backwards and forwards action is sufficient. There is no doubt that where it is possible to use a laminating roller, work is greatly speeded up. It is not recommended that rollers are used in sculpture, where there is a lot of detail, since bad lamination can result, in that the high spots tend to be denuded of resin, and valleys hold too much—glass fibre can be exposed and delamination ensue.

Stage 5—Removing the Laminate
The mould is shown being lifted from the cast, which has been left to harden for approximately twelve hours. The laminate should be eased from the mould gently and evenly all round the edge, air being allowed to enter between mould face and cast. Force should not be used if it is desired to keep the mould for further casts. Where rigid moulds are being used with undercuts, it would, of course, be necessary to smash them off. Warm water, poured via a funnel between the mould and cast faces, will greatly assist release. In the case of plaster moulds, it will be found greatly advantageous to soak the whole thing in water for several hours.

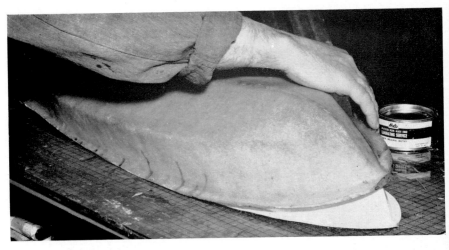

11. The mould being lifted away from the laminated cast (photo: Holt Products Ltd)

22

SECTION D—Reinforcement Techniques and Bonded in Fittings

Once the laminate has been completed, it is normally sufficiently strong in itself for most purposes. However, in the case of large work, it may be desirable to build in reinforcement or stiffeners; and in most laminates it will be necessary to fix in some sort of bolt, mounting device, or fitting: all this work should be carried out at the laminating stage.

Building in Bolts and Fittings. This work should be planned well in advance, and the fittings made ready for laminating into the body of the object being produced, so that they will become a corporate part of the whole. When fixing a bolt in a panel, either a thickness should be built up, to be drilled and tapped at a later stage, or a metal piece

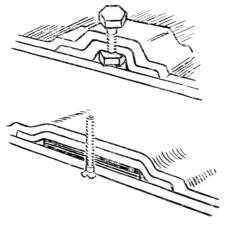

Fig. 12. Built up thickness to hold a nut.

Fig. 13. Metal piece laminated into place for the bolt.

laminated in, together with the bolt (plates 12 and 13). Bolt and nut threads should be lightly oiled before bonding in, to prevent the adhesion of resin.

Of great interest is a new family of laminate fittings, manufactured by Metal Ventures Ltd., and known as **Bigheads** (see plate 14). These new fixing devices have been designed specially for use in glass fibre resin laminates. They consist of thin gauge mild or stainless steel discs, perforated, with steel studs centrally welded to them. (In addition, there are produced perforated steel discs with nuts welded to them known as **Flushnuts**.)

Bigheads are available in a range of sizes, making it possible to put fixtures and fittings onto any laminate, without having to drill through and disfigure the face of the material.

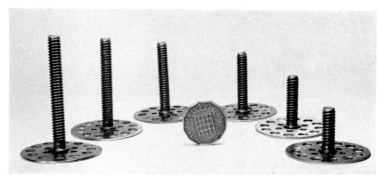

14. Bigheads. Note the large perforated disc head (photo: Metal Ventures Ltd.).

Bigheads strongly resist vibration, and once embedded in a laminate at the laminating stage, only gross misuse will break them. The thin perforated disc allows for moulding it to the contours of the laminate, so that there is a smooth finish on both sides. The stud portion protrudes, and the threads are protected from resin during the laminating stage by a plastic sleeve, which is subsequently removed when the resin has cured. A new stud-welding technique enabling a full strength weld to be made to thin gauge metals, means that a Bighead combines the strength of the metal with the bonding power of a synthetic resin.
Bigheads are available with stud lengths from $\frac{1}{2}''$ to $2''$; the discs are $1\frac{1}{2}''$ in diameter, the studs $\frac{1}{4}''$ BSW.

Method of Fixing. This method is applied to all types of fixing devices, and it is stressed at this point that fittings must be fixed in at the laminating stage, and not bonded in as an afterthought.
After the gel coat has cured, and the first layer of glass fibre impregnated, press a Bighead into position so that the excess resin wells up through the perforations in the disc. Then the remaining layers of glass fibre reinforcement are built up to the required thickness of the laminate. The resin is allowed to cure thoroughly before the plastic thread protector is stripped away, and a load applied to the fitting.
If a laminate subsequently requires the bonding in of a fitting, after it has cured, care has to be taken to avoid delamination between the old and newly applied layers. The surface of the cured laminate must be well roughened, to provide a good bond for the new layers of resin and

24

glass fibre. An alternative method is to take advantage of the fantastic bond strength of Epoxy Resin (Holt's Twinbond is an example). Simply spread the epoxy resin mix onto the roughened and cleaned surface of the laminate, and press the fitting firmly into place; put more mix over the top of the fitting, and smooth evenly around the area. Set aside to cure for at least 24 hours.

Preventing Flexing in a Laminate. Where large flat or curved surfaces are to be produced, two, three or four layers of 1 oz. glass fibre chopped strand mat may be sufficient reinforcement as far as strength is concerned, but not nearly enough to prevent excessive flexing. In this case, to avoid using many more layers of reinforcement, ribs should be inserted or raised on the underside of the laminate. The ribs, or formers, can be made of wood, iron, or even pre-formed glass fibre resin rolls. However, such formers and ribs will have to be specially made to the shape of the laminate. It should be stressed here that the strength of the ribbing does not come from the actual materials used for the rib, but from the actual deformation caused in the laminate itself. There has been a recent development in ribbing materials, taking advantage of this fact, and which obviates the necessity of making time wasting expensive ribs, in awkward materials, and also reduces the overall weight of the laminate.

Paper Rope Formers. Paper rope formers are, in fact, ropes made from paper, and they are a "D" shape in section, being one inch thick. The paper rope has a wire core, so that the rope may be bent to stay in any shape whilst laminating is in process. In this way, the paper rope will easily take the shape of the laminate, however complicated that shape is. Taking a glass fibre laminate with four layers of reinforcement, the paper rope is laid onto the second layer of glass reinforcement, and

15. Section of laminate showing 2 layers of chopped strand mat, paper rope former, and 2 more layers of chopped strand mat.

then the second two layers of glass reinforcement are laminated over the top of the rope (see diagram), producing a "top hat" section in the laminate.

Effectiveness of Paper Rope Formers. A laminate measuring 13″ by 39″, consisting of a gel coat and four layers of chopped strand mat (1 oz. per square foot), fully cured, was supported at its ends, and a 10 lb. weight placed in the middle. The laminate flexed $1\frac{3}{4}″$ at the

centre point. Another laminate of the same size, also with four layers of the same chopped strand mat, but ribbed down its full length twice with paper rope formers (see diagram below), required 3 cwt. to deflect the panel the same distance of $1\frac{3}{4}''$—a thirty-three fold increase in flexural strength.

Method to be Followed. It is important that when ribbing is carried out with ribs and formers, that it is done at the laminating stage, and not after the laminate has cured. Provided the moulding and ribbing are completed in one operation, the ribs will be undetectable on the front of the moulding or casting. Should the ribbing be carried out on a cured laminate, a depression corresponding to the ribs will be visible on the gel coat surface: furthermore, there is a danger of delamination, or separation between the two, since it is not possible to get the same degree of adhesion as at the laminating stage.

After laying the first two layers of reinforcement in the manner already outlined, a length of paper rope, cut to size, is laid on the laminate, flat side down. Since it has a wire core, it will take any shape imparted to it. The final two layers of chopped strand mat are then laminated over the top of the paper rope.

Should it be found necessary to rib a laminate, or even to bond in fittings, after the laminate has fully cured, this can be done successfully, with less danger of delamination, provided the area to be reinforced is roughened; this means thoroughly roughened, and not just scratched.

How Many Layers of Reinforcement? The following is a guide to the number of layers of chopped strand mat to use in a laminate, according to size. Using chopped strand mat, 1 oz. per square foot:
Panels up to 8 feet in length require 4 layers
Panels 8—12 feet ,, ,, ,, 5 ,,
 ,, 12—16 ,, ,, ,, ,, 6 ,,
 ,, 16—20 ,, ,, ,, ,, 8 ,,
The individual requirements of the shape of the laminate itself will dictate the number of paper rope formers to use, and the distance between them, so it is not feasible to make up a chart or table as a guide.

Joining Laminates Together. In cases where two laminates are to be bolted together, Bighead bolts may simply be included in the laminate during construction, so that when the work is finished, the cured pieces may be bolted together without any further drilling or fitting. Brackets may also be bonded into the laminate in a similar manner by

spreading the ends, and then covering them with layers of glass fibre and resin, until the required rigidity is reached.

Butt and lap joints (see illustrations below) are very easily made. In the case of butt joints, the two ends are laid into position, ample overlap of glass fibre being allowed behind the joints: this will give the necessary strength. Lap joints, unless they are very close, should have a layer of glass fibre ribbon between the joints, in order to give extra strength to the resin coat between the joint.

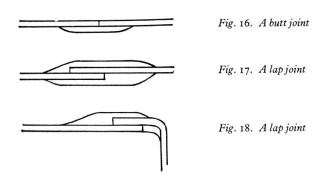

Fig. 16. *A butt joint*

Fig. 17. *A lap joint*

Fig. 18. *A lap joint*

Riveting. This is carried out quite easily by drilling holes in the laminate, and riveting in the normal way. For permanent watertight riveting, a coat of catalysed resin should be painted between the surfaces to be rivetted.

Bonding in Tubes. To bond a tube into a laminate, splay the ends (see diagram below), and then bond in with at least three layers of chopped strand mat; more layers may be necessary if the tube is to take a lot of strain.

Fig. 19a. *Splayed ends of a tube*

Fig 19b. *Splayed ends of tube laminated into position*

Conclusion. The examples shown in this section give the latest ideas on fixing devices and techniques of reinforcement, at the time of going to press. New techniques and developments do appear from time to time, and for the latest information you should write to your resin supplier.

SECTION E—Tools and Ancillary Materials

Few tools are required for polyester resin glass fibre laminating. This section will simply list them, and give notes and illustrations where relevant.

Calibrated Paper Mixing Cups. These disposable cups (see illustration) are marked on the inside with lines, indicating the levels of various weights of resins, from 2 oz. to 20 oz. This obviates the necessity of having to weigh out resin with the aid of scales.

20. Calibrated paper cups.

Laminating Rollers. There are two types (see illustration)—disc and finned. Each type is made in two sizes. The finned type is the most efficient in use, but it is considerably more expensive than the disc roller.

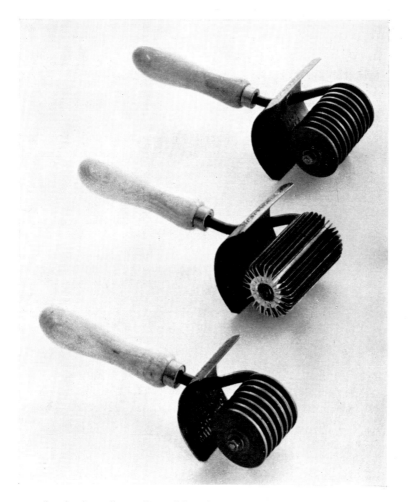

21. Laminating rollers—disc and finned.

Polyester Resin Solvent. For cleaning gelled and freshly hardened resin from brushes, tools, etc. Use in a well ventilated room, since the smell is slightly toxic, and will cause headaches. This solvent is non-inflammable.

Chrome Cream. Chrome metal polish. This has been tried and tested, and has been found one of the best polishes for cold cast metals.

Polyester Brushes. These brushes are specially made for use with polyester resins. The bristles are set in solvent proof rubber, and the handles are unvarnished.

Barrier Cream. Kerrodex 71 is suitable as a barrier cream for the hands and wrists. The cream should be applied, and rubbed well into the skin before handling polyester resin.

Cleansing Cream. Kerrocleanse should be used in conjunction with Kerrodex 71. Use the cream to remove resin from the hands; this will obviate the necessity of continually washing the hands in harmful solvents which wash the natural oils from the skin.

SECTION F—Cleaning Tools, etc.

Tools, utensils and brushes should always be cleaned before the mix has gelled; otherwise, once the resin has gelled and cured, it cannot be removed by ordinary solvents, but only by burning (satisfactory only for metals, or fireproof glass rods), or by overnight soaking in one of the following chemicals: methylene chloride, ethyl acetate, ethylene chloride, non caustic types of paint remover, or Scopas Polyester Resin Solvent. Ungelled resin is so easily removed with methylated spirits, cellulose thinners, or acetone—any one of these three solvents will keep brushes flexible. However, very soon the thinners used will build up a large content of resin, with the result that a brush cleaned in it will still contain resin after cleaning, and consequently will stiffen.

A second cleaning stage, using a hot strong detergent solution, will then completely clean the brush: however, it is emphasised that the brush must not be used again until it is thoroughly dry, because moisture has a retarding effect on gel times of mixes.

Where small quantities of resin mix are being made up, it is advantageous to use disposable paper cups, or old tins and jars; this will obviate the necessity of cleaning afterwards. Small polythene containers are useful for continuous use, since they are easily cleaned out afterwards—the resin will simply flake off when the container is flexed.

This section contains calculating tables for estimating the amounts of resin required for various areas. Following the resin calculating tables are formulae for finding the surface areas and volumes of all the basic shapes and forms. There are also listed imperial and metric conversion tables for lines, surface areas, volumes and weights, and for Centigrade and Fahrenheit, thus making it unnecessary for the reader to refer to other reference books.

Polyester Resin Calculating Table A

Table A shows the approximate total amounts of polyester resin required for gel coats covering certain areas. Columns 1 and 2 show the breakdown of laminating resin and thixotropic paste resin, and column 3 shows the combined total of the resins. Remember that thixotropic paste resin is not normally used with metal filled gel coats, although it may be used with caution.

Area to be covered (sq. ft.)	Laminating Resin (85 parts) lb. oz.		Thixotropic Resin (15 parts) lb. oz.		Gel Coat Mix (100 parts) lb. oz.	
1		1·6		·25		1·85
2		3·2		·50		3·7
3		4·8		·75		5·5
4		6·4		1·0		7·4
5		8·0		1·25		9·25
6		9·6		1·50		11·10
7		11·2		1·75		12·95
8		12·8		2·0		14·80
9		14·4		2·25	1	0·25
10	1			2·50	1	2·5
20	2			5·0	2	5·0
30	3			7·5	3	7·5
40	4			10·0	4	10·0
50	5			12·5	5	12·5

Polyester Resin Calculating Table B

Showing the approximate amount of polyester resin required to impregnate various types of glass fibre reinforcement. The total amount is made up of 9 parts laminating resin and 1 part thixotropic paste resin.

Area to be covered (sq. ft.)	Chopped Strand Mat 1 oz/sq. ft. lb.	Chopped Strand Mat 1 oz/sq. ft. oz.	Glass Cloth 8 oz/sq. yd. lb.	Glass Cloth 8 oz/sq. yd. oz.	Glass Scrim 5 oz/sq. yd. lb.	Glass Scrim 5 oz/sq. yd. oz.
1		3		0·9		0·55
2		6		1·8		1·10
3		9		2·7		1·65
4		12		3·5		2·20
5		15		4·4		2·80
6	1	2		5·3		3·30
7	1	5		6·2		3·90
8	1	8		7·1		4·40
9	1	11		8·0		5·00
10	1	14		8·9		5·50
20	3	12	1	1·8		11·10
30	5	10	1	10·7	1	0·60
40	7	8	2	4·0	1	6·10
50	9	6	2	12·4	1	11·60

Note. Tiranti Laminating Resin **Type B** is an accelerated blend of 9 parts laminating resin and 1 part thixotropic paste resin; this blend is ready to use, and requires only the addition of the catalyst.

Polyester Resin Conversion Table: Weight to Volume

Polyester Resin lb	Imperial Pints	Imperial Gallons
50·0	35·5	4·4
10·0	7·1	0·885
5·0	3·55	—
2·5	1·775	—
1·0	0·71	—
1·4	1·0	—
11·3	8·0	1·0

1 tablespoon = 14·3 cc
100 cc = 7 Tablespoonsful

Formulae for Finding Surface Areas and Volumes

l = length h = perpendicular height d = diameter
b = breadth from base ch= chord
s = base r = radius π = 3·14

Area of a square = s × s
Area of a rectangle = l × b
Area of a triangle = $\frac{1}{2}$(s × h)
Area of a parallelogram = s × h
Area of a trapezoid = $\frac{1}{2}$(sum of parallel sides × h between them)
Length of the circumference of a circle = π × d
Area of a circle = π × r^2
Area of an ellipse = long axis × short axis × 0·7854

Area of a segment of a circle = $(ch \times \frac{2}{3}h) + \frac{h^3}{2ch}$

Length of circumference of an ellipse = $\frac{1}{2}$(long axis + short axis) × π
Volume of a cube or rectangular vessel = l × b × h
Area of surface of a sphere = 4 × π × r^2

Volume of a sphere = $\frac{4}{3}$ × $\pi\,r^3$

Area of surface of a cylinder = (2 × π × r × h) + (2 × π × r^2)
Volume of a Cylinder = π × r^2 × h

$$\text{Volume of a pyramid} = \frac{1}{3}(\text{area of s} \times \text{h})$$

$$\text{Volume of a cone} = \frac{1}{3}(\text{area of s} \times \text{h})$$

Area of surface of a cone = $\frac{1}{2}$ circumference of base \times slant.

Temperature Conversion Tables

So that more exact control can be obtained when curing the Vinagels in a domestic oven, the chart indicates Regulo settings and the corresponding Temperatures in °F and °C.

Regulo	°C. ← °F.	°C. → °F.	Regulo	
	−6·5	20	68	
	−4·0	25	77	
	−1·0	30	86	
	+1·9	35	95	
	4·5	40	104	
	7·2	45	113	
	10·0	50	122	
	12·9	55	131	
	15·5	60	140	
	18·2	65	147·2	
	21·1	70	158	
	23·9	75	167	
	26·2	80	176	
	32·2	90	194	
	37·8	100	212	
	40·6	105	221	
	43·3	110	230	
	46·1	115	239	¼
	48·9	120	248	
	51·7	125	257	
	54·4	130	266	½
	57·2	135	275	
	60·0	140	284	
	62·7	145	293	1
	65·5	150	302	
	68·3	155	311	2
	71·0	160	320	
	73·8	165	329	
	76·6	170	338	3
	79·3	175	347	
	82·1	180	356	4
	85·0	185	365	

Regulo	°C. ← °F.	°C. → °F.	Regulo	
	87·8	190	374	
	90·0	195	383	5
	93·3	200	392	
	96·1	205	401	6
	98·9	210	410	
	101·6	215	419	
	104·4	220	428	7
	107·2	225	437	
	110·0	230	446	8
	112·7	235	455	
¼	115·5	240	464	
	118·2	245	473	9
	121·0	250	482	
	123·8	255	491	
	126·6	260	500	
½	129·4	265	509	
	132·2	270	518	
	135·0	275	527	
	137·7	280	537	
	140·5	285	545	
1	143·3	290	554	
	146·1	295	563	
	148·9	300	572	
	151·7	305	581	
2	154·5	310	590	
	157·2	315	599	
	160·0	320	608	
	162·8	325	617	
	165·6	330	626	
3	168·4	335	635	
	171·1	340	644	
	173·9	345	653	
	176·7	350	662	
4	179·5	355	671	

Linear Conversions

Centimetres into inches	multiply by	0·3937
Inches into centimetres	,, ,,	2·540
Millimetres into inches	,, ,,	0·0394
Inches into millimetres	,, ,,	25·4
Metres into Inches	,, ,,	39·370
Inches into Metres	,, ,,	0·0254
Metres into Feet	,, ,,	3·2808
Feet into Inches	,, ,,	0·3048
Metres into yards	,, ,,	1·0936
Yards into Metres	,, ,,	0·9144

1 inch = 0·083 ft., 0·0278 yd.

Surface Area Conversions

Square centimetres into square inches	multiply by	0·155
Square inches into square centimetres	,, ,,	6·4516
Square metres into square yards	,, ,,	1·196
Square yards into square metres	,, ,,	0·8361
Square feet into square metres	,, ,,	0·929
Square metres into square feet	,, ,,	10·764

Volumetric Conversions

Cubic Centimetres into cubic inches	multiply by	0·061
Cubic inches into cubic centimetres	,, ,,	16·387
Cubic metres into cubic yards	,, ,,	1·308
Cubic yards into cubic metres	,, ,,	0·765
Cubic centimetres into pints (Imperial)	,, ,,	1760·0
Litres into pints (Imperial)	,, ,,	1·760
Pints into cubic centimetres	,, ,,	568·26
Pints into litres	,, ,,	0·568
Litres into gallons	,, ,,	0·220
Gallons into litres	,, ,,	4·546
Gallons into cubic feet	,, ,,	0·1605
Cubic feet into gallons	,, ,,	6·229
Fluid oz into cubic centimetres	,, ,,	28·4
Pints into fluid oz	,, ,,	20·0

Weight Conversions

Grammes into ounces	multiply by	0·035
Ounces into grammes	,, ,,	28·349
Pounds into grammes	,, ,,	453·592
Pounds into grains	,, ,,	7000·0
Kilogrammes into pounds	,, ,,	2·205
Pounds into kilogrammes	,, ,,	0·454
Ounces into grains	,, ,,	437·5

Chapter 4

Cold Casting in Metal Techniques

Cold Cast Metal has now come to be generally accepted as a serious new material for sculpture, opening up unlimited possibilities in size, techniques and forms. Finished casts may be put indoors or out, have no weight problems, and may easily be repaired. Costs are relatively low when compared to lost wax casting, and highly skilled labour is not required. There is no doubt that Cold Casting in Metal, and glass fibre reinforced polyester resins are bringing about a revolution in sculpture, and may prove to be the herald to a more extensive use of polyester resins in many walks of life in the not too distant future.

Chapter three dealt fully with making a glass fibre laminate. Cold casting in metal is basically the same technique, slightly adapted for use in sculpture. This chapter, therefore, will deal with laminating techniques applied to sculpture, and incorporating metal fillers.

Section A—**Moulds**
Section B—**Mixing Metal Fillers and Components**
Section C—**Casting a Life Size Head**
Section D—**Plaques and Masks**
Section E—**Awkward Casts**
Section F—**Footnote on Fillers**
Section G—**Finishing**

It cannot be stressed too much that brushes and tools should be kept scrupulously clean as you go along (see chapter 3, Section F). And also, if the user has an extra sensitive skin, barrier cream should be applied to the hands, wrists and arms before commencing work. In any case, it is always an advantage to use barrier cream on the hands before handling polyester resins, because it is then much easier to remove the resin from the hands using the Cleansing Cream.

SECTION A—Moulds

General. Normally in sculpture, plaster waste moulds are used; that is to say, only one cast will be made in the mould, and the mould sub-

sequently broken away from the finished cast. A special one coat parting agent, Bellseal, is used to ensure complete release of the finished cast from the mould. The alternative parting agent would be a combination of wax and P.V.A. (see chapter 3), but complete treatment of sculpture moulds with these materials is generally impossible. Other materials used for moulds are Vinamold, and Silicone Rubber. Vinamold is a hot melt flexible moulding compound; it will yield a limited number of casts in polyester resin (a dozen or so), but it may be melted down and reused for making further moulds. Silicone Rubber (Silastomer), on the other hand, will yield an almost unlimited number of casts in polyester resin, but it cannot be re-used, and it is four times the price of Vinamold. The possibilities of using a combination of Vinamold and Silastomer should be explored—the Silastomer being used for the mould face, and the Vinamold being used as a backing. Both Vinamold and Silastomer are fully dealt with in later chapters in this book; neither moulding material requires a parting agent for polyester resin. It should be noted that gelatine moulds are not reliable moulds for use with polyester resins.

A word here about mould edges. It is normal practice in laminating to take the gel coat well over the edge of the mould, and to do the same with the subsequent laminations of glass fibre and resin, to facilitate subsequent removal of the cast, and, more important, to allow for trimming to produce a good edge. In sculpture, this is even more important for a

22. *Reclining figure* by F. I. Kormis. In cold cast bronze (photo: F. I. Kormis)

further reason, particularly when using flexible moulds. Should the gel coat not be carried well over the edge of the mould, it is sometimes possible that the lay up mixture will trickle down between gel coat and mould face, resulting in an unwanted surface layer of resin.

Preparation of the Mould. Moulds may be divided roughly into three types—porous, non-porous, and flexible. Porous moulds, such as plaster, should be thoroughly dried out, and then given one good coat of Bellseal. Allow the Bellseal to dry thoroughly before casting. Do not force dry the Bellseal, nor leave it too long once dry (more than, say, overnight), since it will otherwise lift from the mould surface. If the Bellseal is not allowed to dry out thoroughly, it is likely that the gel coat will break down some of the Bellseal, and form into extremely hard surplus bits and pieces, which will adhere firmly to the cast. Non-porous moulds such as glass, metal, china, etc., are rarely used for sculptures, and their treatment will not be dealt with at length in this this chapter. Section B of chapter 3 deals fully with the various systems of obtaining release from non-porous moulds. Flexible moulds, such as Vinamold and Silastomer, do not require parting agents.

SECTION B—Mixing Metal Fillers and Components

Metal Fillers. There are seven metal fillers—aluminium, brass, bronze, copper, iron, lead and nickel silver. These fillers may be used by themselves, or mixed together (in their dry state first) in order to obtain a wide variety of effects. It is not possible to give exact proportions for resin/metal mixes. In practice, a good guide is to mix equal parts **by volume,** and then experiment by brushing out on a test surface. In the case of bronze, it will be found that nearly six parts **by weight** of metal powder, to one part of resin, will give a good metallic finish. It is important to note that if a thixotropic mixture is being used, no less metal filler should be incorporated, even though the mixture will appear slightly stiffer—the mix will still brush out comfortably. Since aluminium is much lighter in weight than bronze, far less weight of powder is required, and probably $1\frac{1}{4}$ parts by weight of powder will be found about right. It is vitally important, however, that plenty of metal filler is used, because otherwise a "plastic" effect will be obtained, instead of a metallic finish.

Try A Test Mix First. It is only by practice that the caster will become au fait with the exact quantities needed, and the small test amounts should be made in order to determine them. If insufficient metal powder is incorporated, then a weak looking metal effect is obtained; in the case of bronze, for example, it will look rather like chocolate. If too much metal filler has been used, then the surface will be pitted with air bubbles. If the mixture has been insufficiently stirred, the surface of the cast will probably have tacky or dry powdery patches, which will eventually crumble.

Warning. Do not make up a large quantity of metal/resin mixture, to last for a day or so. Make up only sufficient mix for the immediate work to be done. Should a metal/resin mix be left to stand, without the addition of the catalyst, for too long (two hours or more), then the mixture will change its chemical structure; this will result in a hard rubbery substance on the eventual addition of the catalyst, and the mix will never cure to a rock hard finish.

Liquid Hardener. When metal fillers are used, it is necessary to increase the normal amount of liquid hardener from 1% to between 2% and 4% (or 12 to 24 drops per ounce of polyester resin). Aluminium filler will require little more than 1%, but any metals containing brass will require more, since they have a tendency to inhibit the curing cycle. Remember that hardener (catalyst) should be measured out according to the weight of the **resin** content of the mixture, and **not** the total resin/metal weight.

Working Temperatures. The ideal temperature for working with polyester resin is 67°F (average room temperature). Temperatures much in excess of this will reduce hardening time. However, temperatures below 67°F will increase the curing time, and the use of additional accelerator may be found useful in temperatures down to 50°F. It is not advisable to attempt laminating below this temperature. Draughts and humidity should be avoided, since they will delay curing, and sometimes even result in undercuring. The use of an electric fire with an in-built fan, resting on the bench fanning warm air towards the work is highly successful. Do **not** use a naked flame to warm a curing laminate.

23. *Epicentre*, by Franta Belsky, FRBS, ARCA. In cold cast aluminium (photo: Franta Belsky).

SECTION C—*Casting a Life Size Head*

Using a two piece plaster waste mould, there are two methods of making a Cold Cast Metal cast of a life size head. One is to cast the two halves separately, and then join them together. The other is to make the cast in one single piece, with the mould assembled. The techniques of the two methods are slightly different, and will serve to illustrate two ways of going about the same job. Undoubtedly, method one is the easiest way to make a cast.

Method One—The Split Mould. By this method, the head will be cast one half at a time, and then the two halves joined together. It is assumed that the two pieces of the plaster mould have been treated with Bellseal, and that they are ready for casting.

Stage 1—Making the Metal/Resin Gel Coat Mix. Make up a mixture of polyester laminating resin and metal filler powder, and mix thoroughly. Remember that as much metal as possible must be used, so that the mix is brushable and just pourable. Once the metal and resin are mixed, add the appropriate amount of hardener, which is normally between 2% and 4% by weight (to the resin content), or 12 to 25 drops per ounce of resin, and again mix thoroughly. It may be found advantageous to use a small amount of thixotropic paste resin in the gel coat mixture. In this case, use 1 part of thixotropic paste resin to 9 parts of laminating resin (mix as described in chapter 3, section A), before adding the metal powder. It should be noted, however, that even though the mixture will appear thicker when using thixotropic paste, no less metal powder should be used. Only make up sufficient resin/metal mix for the job in hand.

Stage 2—The Gel Coat. Paint the metal gel coat mix into one half of the mould, going up to, but not over the flashing edge, but going well over the edge at the neck. Take care that no air is left trapped in the detail, particularly the ears. Allow the gel coat to harden, making sure that there is no drainage from the sides of the mould, causing a pool of mixture to collect at the lowest spot; this may be done by slowly turning the mould, so that the gravity pull on the heavy mix is overcome. When the gel coat has cured, the high spots in the mould should be inspected, to make sure that they are well covered. If there are any bare patches, an extra thick resin/metal mix should be made up (do not forget to add hardener) and put onto the high spots with a spatula. When the gel coat has cured, the above procedure should be carried out on the other half mould.

Stage 3—Laminating the two Half Moulds. When the metal gel coat in the two half moulds has cured, it must be reinforced with glass fibre, that is to say laminated. One half mould should be laminated at a time. First, cut up sufficient pieces of chopped strand mat to cover one half mould two or three times. Make up a laminating mixture of 1 part thixotropic paste resin, and 9 parts laminating resin (see chapter 3,

24. Wall relief in the Co-operative Insurance Building, Manchester, 1963, by William Mitchell, DesRCA, AIBD. Cold cast bronze from a polyurethane mould (photo: William Mitchell & Associates Ltd.).

section A), so that there is sufficient to laminate both half moulds. Pour off some of the mixture into a bowl (no more than you can use in half an hour), and mix in 1% of liquid hardener. Paint some resin onto the metal gel coat, and lay on a piece of chopped strand mat. Keep well clear of the flashing edge, leaving some of the gel coat exposed, but go well over the edge of the mould at the neck. Work the resin through the glass fibre with a brush, using a stippling action, until the glass fibre becomes completely transparent; this indicates correct impregnation. Make sure that no air bubbles are trapped beneath the glass fibre, and take care to reinforce the ears thoroughly. Carry on painting in resin, and laying in glass fibre until the half mould has been covered two or three times. It does not matter that the previous layer of glass fibre and resin has not cured, before the next is laid on. Repeat the process in the other half mould, remembering to have cut up some chopped strand mat to size, ready to use. At this stage, mounting bolts could be conveniently fitted into place (see chapter 3, section D), using resin and glass fibre reinforcement. If any extra thickness is required, use a mixture of thixotropic paste resin, with accelerator and plenty of inert filler powder (plus hardener, of course!).

Stage 4—Joining the two Half Moulds. When the two half moulds have cured, tie them securely together. Make up sufficient resin/metal mix to cover the seams (do not forget to add hardener), and pour the mix into the mould down the seams. Make sure that the metal mix covers the seams right round; the use of a long handled brush may be found useful in some cases. Keep the mould on the move until the mix has cured, so that there is no excessive drainage. Next cut up some strips of chopped strand mat, about 1″ wide, sufficient to cover the seams twice over, and make up more laminating mix (1 part thixotropic paste, 9 parts laminating resin, and 1% liquid hardener). Working on one area at a time, paint the mix over the seams, and well onto the adjoining cured glass fibre reinforcement already in position. Lay in strips of chopped strand mat, one at a time, and completely impregnate them. Make sure that the strips overlap the cured glass fibre reinforcement already in position, so as to make a continuous reinforcement across the seam. Carry on laminating the seams until there are at least two layers of glass reinforcement. An alternative way of laminating the seams is to lay in strips of chopped strand mat, already impregnated with catalysed resin; however, this method tends to trap air under the glass fibre, unless great care is exercised, and also the sculptor's hands cannot be prevented from becoming well coated with resin.

44

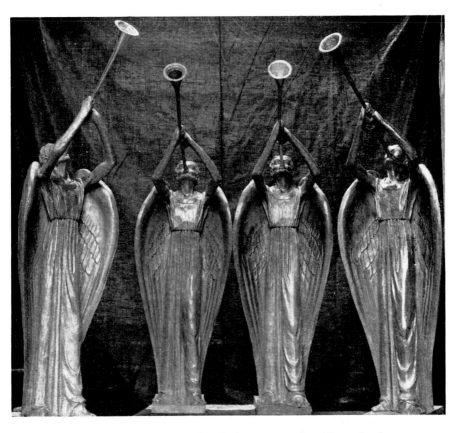

25. Four Angels, 1960, by Miss Kathleen Parbury, A.R.B.S., in cold cast alumin-
ium. These figures are 5′ 4″ in height (photo: Kathleen Parbury)

Stage 5—Removal of the Cast from the Mould. The cast should
be left to cure completely whilst still in the mould. It will be found
very useful to allow warm air from a turbo-flow, or fan-heater, to blow
into the mould, particularly in cold weather, to make a fast and complete
cure. Once properly cured—several hours at least—soak the mould in a
bucket or bath of water, preferably warm. This will weaken the plaster,
and at the same time, turn the Bellseal to slime, since it is water soluble.
The mould is then very easily chipped away from the cured cast. Trim
the neck with a fine hacksaw, and clean away the flashings. If any
patching is required, make up an extra thick resin/metal mix, and build
up or patch with a modelling tool.

45

Method Two—The Whole Mould. By this method, the mould is tied together, and the cast made in one piece.

Stage 1—The Gel Coat. Make up the same mixture as described in stage one above, but this time sufficient to cover the whole mould at one time. Pour the mix into the mould, and turn it slowly, until there is a coating of mixture over the whole mould; take care particularly with the ears, and make sure that the mix goes well over the edge of the mould at the neck. Keep the mould turning slowly, until the gel coat has hardened. Do not stop turning the mould when the mix gels, since with the heavy loading of metal filler, the gelled mix will not be able to support itself where it overhangs. When the gel coat has cured, check the high spots in the mould to see that they are covered with metal. If there are any bare patches, make up a very thick resin/metal mix, and trowel it over the bare spots with a spatula.

Stage 2—Laminating. When the gel coat has cured, cut up some pieces of chopped strand mat, sufficient to cover the inside of the mould at least twice. Make up a laminating mix (1 part thixotropic paste resin to 9 parts laminating resin), sufficient to laminate the whole head. Pour off some of the mix into a bowl (as much as you can use in half an hour), and mix in the hardener, 1% by weight. Working one area at a time, paint in the resin, and lay in the glass fibre, impregnating it with a brush, using a stippling action. It may be necessary to adapt an ordinary brush for laminating, by mounting it at an angle, on a rod. Carry on laminating until the inside of the head has been covered by at least three layers of glass reinforcement. Particular care should be taken with the ears, and the glass fibre reinforcement should be taken well over the edge of the mould at the neck. A mounting bolt should be fitted at the laminating stage. The cast should be removed from the mould as in stage 5 above.

SECTION D—Plaques and Masks

Plaques, masks and reliefs are probably the easiest to cast in glass fibre reinforced polyester resin. The same technique should be used as with the split mould technique described above. However, it should

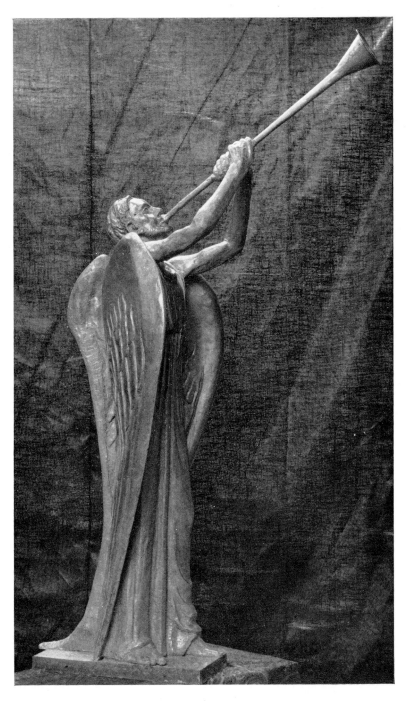

26. One of the angels shown on plate 25 (photo: Kathleen Parbury)

be remembered that the gel coat and glass fibre reinforcement should be carried well over the mould edge **all round,** to allow for trimming to a good edge. Mounting fittings should be laminated into the cast, being fitted in between layers of glass fibre (see section D of chapter 3). Where very large wall reliefs have to be cast, they could in fact be cast in sections, each section with a return edge. All the sections can then be bolted together and glued, at the site. If a very large relief is to be cast in one piece, it may be desirable to incorporate ribs at the laminating stage to make the panel completely rigid. In this case, paper rope formers should be used as described in chapter 3, section D.

SECTION E—Awkward Casts

It is not possible to lay down hard and fast rules on casting small figures and awkward shapes. The techniques are basically as described in section C of this chapter, but the main thing to keep in mind is that **you must always be able to work the mould properly.** In other words, make a mould in as many pieces as is necessary to enable you to put in the gel coat, and to laminate safely and adequately. In the case of a figure, it may be necessary to make one mould of the front half of the figure, and then to make the other half of the figure in several pieces. Each part of the mould should be finished, as in the split mould technique, and then all joined together, piece by piece, until there is a small piece in the back to drop into place. In some cases, where the mould or part of the mould is very tiny, it may be found advantageous to fill the mould solid; in this case use a mixture of laminating resin (9 parts), flexible resin (1 part) and add pieces of torn up chopped strand mat, or "Cosywrap" glass fibre, to make a stodge. The stodge should be gently rammed into place until the cavity is filled up.

SECTION F—Footnote on Fillers

This chapter has described the technique of making a cold metal cast, using the **Scopas** type of metal filler. It should be stressed here that the ordinary flake metal powder, used for painting, is not a suitable filler for polyester resin.

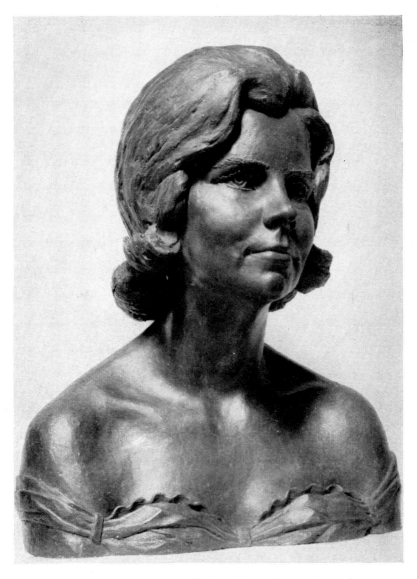

27. *Angela*, 1962, by Lewen Tugwell. In cold cast bronze (photo: Lewen Tugwell).

Sculptures may be made in glass fibre reinforced polyester resin, without any fillers at all. In such cases, the gel coat should contain at least 15% of thixotropic paste resin. Such casts will tend to be translucent, but they may be self coloured by use of one of the polyester pigments.

Other types of fillers should be tried out, and there should be no hesitation in trying out new ideas and fillers. A few fillers which can be used are slate powder, marble dust, stone dust, glass powder, and wood flour. The only important things to remember are that the fillers must not react with the resin, and that they must be absolutely dry. Test mixes will reveal suitability.

28. COUNTERTHRUST II, by Roger Leigh. In cold cast copper (photo: Roger Leigh)

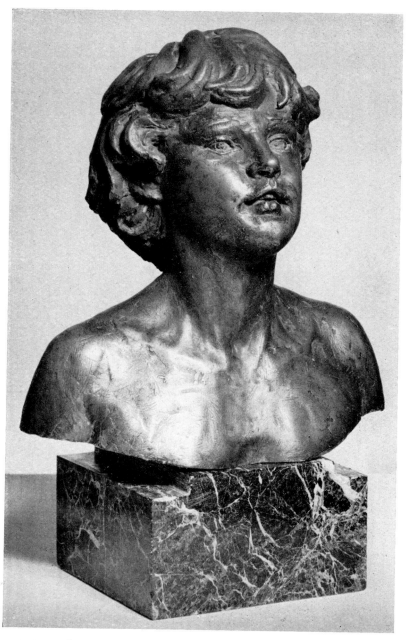

29. *Janet Thompson*, 1963, by Alex C. Schwab. In cold cast bronze (photo: Jack C. Adams).

Cold Cast Metal casts should be left for at least six hours, preferably longer (12-24 hours), before any sort of polishing is carried out. Polishing may be effected by means of jewellers' rouge, Holt's Chrome Cream, and similar metal polishes. Where very large panels have to be polished, a very fast wheel and a very fine buffing compound may be used with great care, in order not to penetrate right through the comparatively thin metallic coat.

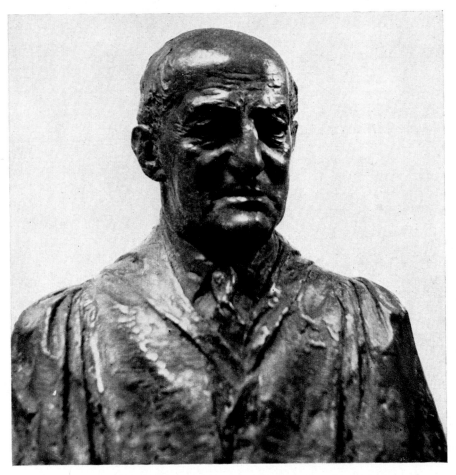

30. *Sir Arthur Thomson*, M.C., M.D., F.R.C.P., PP.B.M.A., 1960 by Franta Belsky, F.R.B.S., A.R.C.A. In cold cast bronze (photo: Franta Belsky)

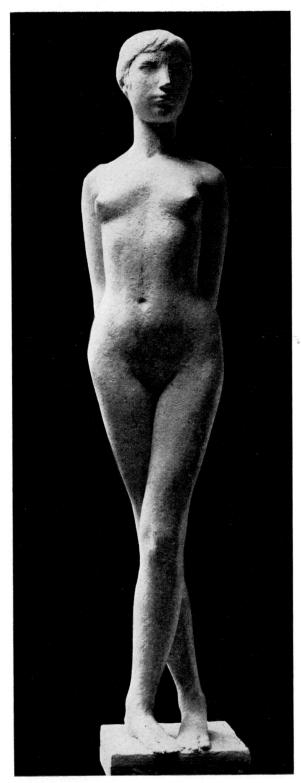

31. *Girl* by Franta Belsky,
F.R.B.S., A.R.C.A. In cold
cast bronze, patinated ver-
digris. Height 6 ft. (photo:
Franta Belsky)

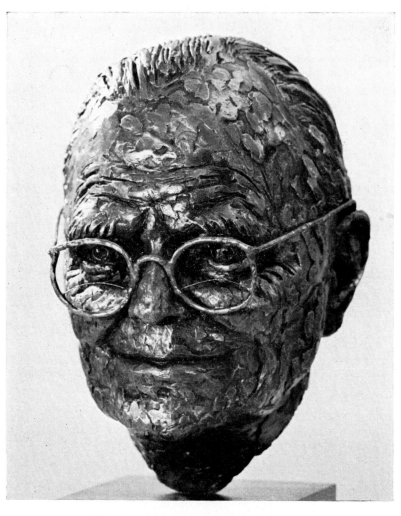

32. *Herbert William Cremer, CBE, MSc, FRIC,* 1964, by Anthony Gray, ARBS.
In cold cast bronze (photo: Anthony Gray).

Patination. The successful patination of metals is extremely difficult and there are no hard and fast rules. Any two people using the same formula and technique, will produce different effects, while a third person may even fail to produce any sort of desirable effect at all.

54

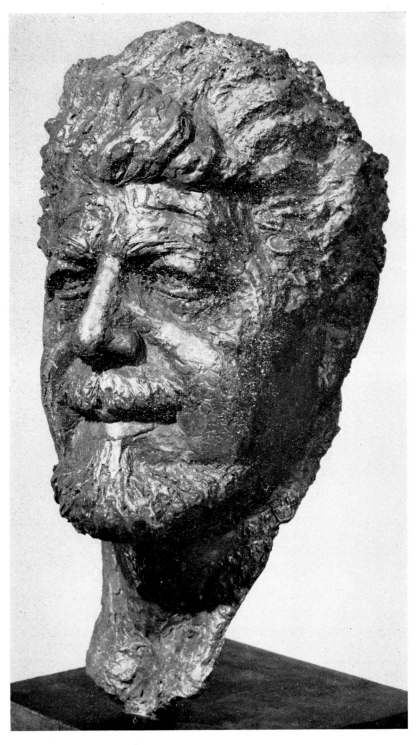

33. *Mervyn Levy*, by Anthony Gray, A.R.B.S. In cold cast bronze (photo: Anthony Gray)

Normally, only organic acids such as acetic acid are used, since the mineral acids (particularly chlorides) tend permanently to damage the surface of the cast. There are three basic ways of producing a patina on metal:

Application of acids by brush or bath

Fuming

Application of waxes and lacquers

There is no doubt that the best patinas are produced by fuming, although it may take several weeks to produce the desired effect.

Patination of Cold Cast Metals. The patination of cold cast metals is a little more difficult than that of pure hot cast metals. The cold cast metals are more resistant to acids, and it seems difficult to find a happy medium between an impervious surface, and one that is pitted by the application of strong acid solutions. There is a lot of room for experiment on the patination of cold cast metals, and it may well be that a different approach must be made. Here are several ideas which have been successfully tried out.

Acid. Concentrated hydrochloric acid produces a very good apple green patination in a very short time, and without etching too deeply into the surface of the cast. Great care should be taken in using this concentrated acid, and expert advice should be sought before attempting to mix the acid with water. The patination should be fixed with a polish made from beeswax and turpentine.

Staining. The surface of the cast should be very carefully etched with acid, or taken down with fine wirewool and then stained with a spirit stain of the desired colour; allow to dry off completely. A beeswax/turpentine polish should then be applied and polished up with a soft cloth.

Waxes. Polish the high spots of the cast with Chrome Cream, until they have a high finish, and the metal has annealed to a continuous surface. A wax polish should then be applied, having been heavily pigmented with concentrated powder colour; alternatively, use one of the heavily pigmented shoe polishes which are readily available.

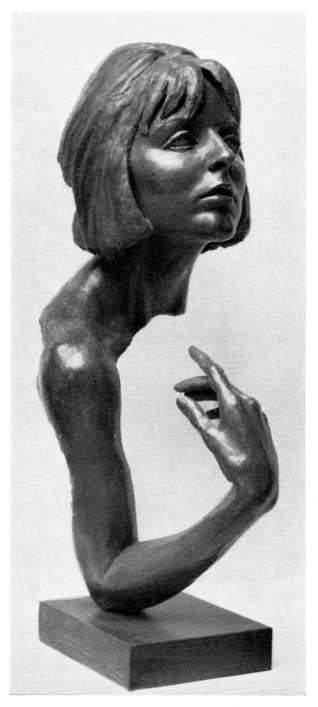

34. *Louise—Ballet Dancer*, 1962, by Lewen Tugwell. In cold
cast bronze (photo: Lewen Tugwell).

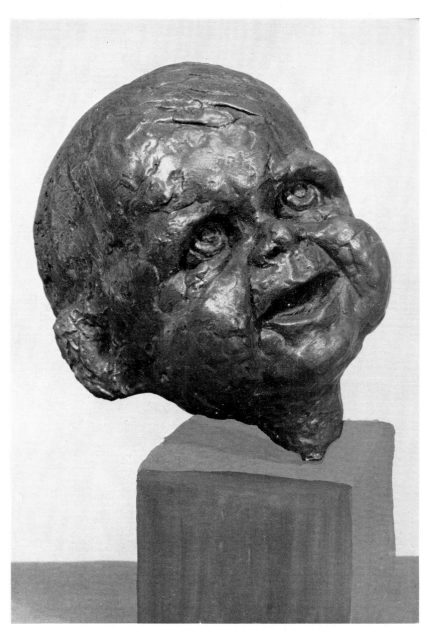

35. *Baby's head*, by Anthony Gray, A.R.B.S. In cold cast bronze (photo: Anthony Gray)

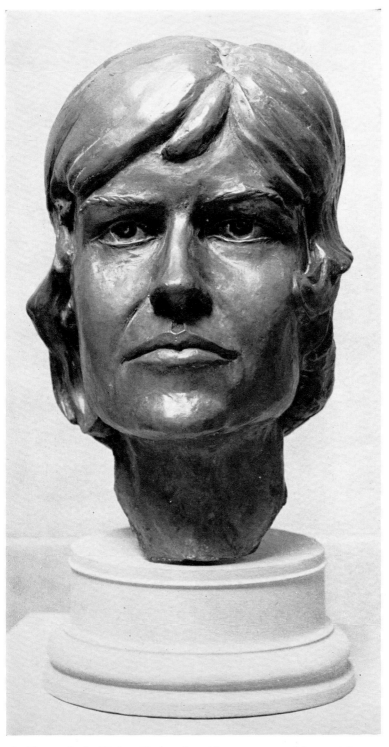

36. *Yves*, 1960, by Herbert Dacker. In cold cast copper and bronze (photo: Herbert Dacker)

37. Lamp base, three feet high. By Tatiana Pomus Alving. In cold cast copper and old silver (photo: Tatiana Pomus Alving).

38. *The Rt. Hon. Earl Attlee*, by Anthony Gray, ARBS. In cold cast bronze
(photo: Anthony Gray).

Chapter 5

Modelling Direct in Polyester Resin/Glass Fibre

An interesting, and comparatively new method of direct modelling in polyester resin/glass fibre, utilises as the binding medium a type of glass fibre normally supplied for insulating roofs of houses. This method, using COSY-WRAP glass fibre, was developed by the sculptor, Mr. Bainbridge-Copnall, M.B.E. (see plate 39). The glass fibre is supplied in the form of a one-inch thick blanket of approximately fifteen inches width. Inert filler powder is used as a working ingredient. Pour laminating resin into a bowl, and add the normal recommended amount of liquid hardener. Tear pieces of COSY-WRAP into a convenient size, and mix them thoroughly into the resin mixture. Inert filler powder should now be added and also colour pigment, if required, and the whole mix kneaded with the hands into a stiff consistency. (It is recommended that those with sensitive skin, use a barrier cream to protect the hands).

When the desired consistency is reached (this is controlled by the amount of filler powder added), the mix is ready for use. The modelling mixture should be built up over expanded metal, or a paper core. It will get stickier as it is being worked, and further filler powder should be added to obviate this. The mixture has a working life of between 30/40 minutes before it sets hard. This setting time may be speeded up still more with extra accelerator. Once again, one should gain familiarity with the method, before attempting anything large.

When the model has hardened, a metal coating may be added to give the whole thing a metallic appearance. As much metal as possible should be added to the mix; this will make a solid metal finish, and at the same time make the mix sufficiently stiff to stop it from running down. If the model's surface has been formed for more than twenty-four hours, roughen it before applying further resin mix. Once the metal coat has set hard, it may be worked with rifflers, wire wool, etc.

39. *The Astronomer* (10 ft. 6 in.) built up in glass fibre over a phosphor bronze armature, Paddington Street, London, by E. Bainbridge-Copnall M.B.E. (photo: courtesy the Sculptor)

Chapter 6

Repairing Broken Metal Casts

Various techniques are outlined in this section which enable strong rigid repairs to be made to broken metal sculpture. In addition, a technique is outlined for filling gaps that result from lost pieces. For easy reference, this chapter is divided into four parts, as follows:

1. Small fractures.
2. Large fractures.
3. Compound fractures.
4. Gap filling.

Small Fractures are those types of fracture where little strain will be imparted to the repaired joints, and where there is no need for internal reinforcing. All dirt, dust, oil, grease, etc., must be cleaned away from the edges of the fractures, and the cleaned edges lightly coated with a mixture of epoxy resin adhesive, such as Holt's TWINBOND. It should be remembered that only sufficient adhesive need be applied to coat both surfaces lightly. The thinner the layer of adhesive between the two metal parts, the better. (This type of adhesive develops a strength of well over a ton per square inch in shear when fully cured. It will be seen that it has more than sufficient strength for this sort of application.) The parts are then brought together and clamped securely whilst the adhesive is setting. An infra-red lamp or electric fire should be so positioned that the area under repair can be heated to between 80-100°C for a period of one hour (at lower temperatures, correspondingly longer).

Large Fractures, where a certain amount of load will be experienced at the point of the fracture, need internal reinforcing. Where the repaired part will exert a leverage when in position, at the point of fracture, some form of internal support must be provided. The following instructions apply specifically to the repair of an extended arm of a metal statue. However, the principle may be applied to a wide range of repairs.

Iron piping of an appropriate thickness should be used. The object

is to fix the tube inside one of the two pieces to be joined, leaving an equal length protruding; this end is then similarly fitted into the fractured part. The pipe is supported internally by means of wooden plugs, which are a very loose fit round the iron tube. (See fig. 40.)

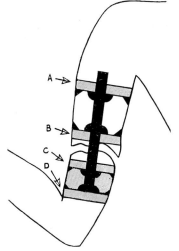

STAGE I.A. *First wooden plug fixed in place with paste mix, and allowed to set.*

STAGE II.B. *The second plug and the pipe are coated with a paste-mix at all contact points, positioned and clamped and allowed to dry.*

STAGES III.C. & D. *The 3rd and 4th wooden plugs are fixed in place. (make hole in C so large as to allow for alignment).*

STAGE V. *The fractured edges between B & C are coated with a Twinbond mix, after having filled space between plugs C and D with a liquid mix. The whole is then carefully brought together and clamped.*

Fig. 40 *Large load bearing fracture*

Stage I—Cement first wooden plug (A) well into the arm, having coated the outside of the plug with a stiff paste mix of polyester resin, inert filler powder, liquid accelerator, and liquid hardener. A high proportion of accelerator should be added, so that the cement will set rapidly.

Stage II—When the first plug (A) has set, the second (B) and the tube are inserted into the arm. Both the end of the tube, and the area of the tube to be covered by plug B, are coated with paste mix; at the same time, the plug is coated round the edge and fixed into the arm—so positioned, that as much space as possible is left between plugs A and B, to give greater strength.

65

Stage III—The third wood plug (D) is cemented and inserted similarly into the end of the fractured part of the arm. A hole is **not** drilled in plug D. A paste mix is carefully applied so that a complete seal is formed all round the plug.

Stage IV—The fourth plug (C), with the usual hole, is next fixed into position and allowed to set.

Stage V—All is now ready for the final fixing. Clean the two fractured edges, and lightly coat with a TWINBOND mix. Make up a semi-liquid paste mix of laminating resin, accelerator, hardener and inert powder, which is just pourable. Pour the mix through the hole in plug C until it is nearly filled. As before, this should be a quick-setting mix.

Bring the fractured parts into position, pushing the pipe end through the hole as far as possible, carefully aligning the fractured edges. The whole assembly should be clamped together quickly, because the mix will set rapidly. The polyester resin mix round the tube must gel before the epoxy resin TWINBOND is warmed to complete its cure (as described in Section 1).

Stage VI—Clean up as before, and if necessary make up a polyester resin/metal mix, utilising the appropriate metal powder, to fill in any gaps at the point of fracture (ve-ed out). Experiment may be necessary to determine the exact shade of the metal mix which might have to include lamp black to darken, or perhaps a combination of various metal powders.

Fig. 41 Broken edges coated with a Twinbond mix, clamped and warmed a little

Compound Fractures. These may need the use of both polyester and epoxy resins, as large fractures do. The object of the polyester resin is to apply glass fibre reinforcement behind the repaired broken pieces. The pieces should be joined together, a

TWINBOND mix first being lightly coated on the edges of each section, and then clamped into position and heated, (fig. 41). When an appropriate number of sections have been joined together, they should be reinforced with several layers of chopped strand mat and resin, (see fig. 42). If the material is non-porous, roughen up the under surface if possible with a sharp instrument.

x. 1st resin coat allowed to set before the layer of glass fibre is laminated into position.
y. The glass fibre laminate.

Fig. 42 Side view showing glass fibre reinforcement to support the repaired structure

Final joining of the various completed sections should be carried out in the same way. When laminating the reinforcement, an ordinary polyester resin mix is utilised. The first coat of resin should contain some thixotropic paste resin, to prevent the mix from running too much. Secondary coats should not contain thixotropic resin.

Fig. 43 Dotted line shows wooden panel inserted into the gap. The edge is coated with a paste-mix, and is held tightly in place by means of a string tied to a screw in centre of panel

Fig. 44 Shows holed section with wooden panel filling gap. The sunken part can be subsequently filled and finished to contour

Gap Filling. Where pieces have been lost, and it is desired to fill the gaps, the following method should be used. Cut a piece of wood in such a way that it can be inserted into the hole, yet overlap it all round. The wood should have a screw in the centre, with a piece of string tied to it, (fig. 43). Make up a stiff paste of laminating resin, filler powder, accelerator and hardener, and liberally coat the face edges of the wood. Manoeuvre the piece of wood into position by holding the screw, and then pull the wood onto the inside area of the hole, so that the paste mix will act as an adhesive. Tie the string so that the wood section is held into place until the mix has set, (fig. 44).

When the resin has set hard, carefully remove the screw, and apply a fresh paste mix over the wood part now covering the hole, to just about $\frac{1}{16}''$ below the level of the surface of the main body of the piece being mended. The resin/metal coat is then laid onto this, slightly proud, and carved up afterwards. Always try and put as much metal as possible into the mix when laying the metal coat.

* * * *

These four main principles, with their many variations, can be used to effect almost any repair to damaged objects including casts in metal, plastic, china, etc.

68

Chapter 7

Vinamold Hot Melt Moulding Compounds Types and Melting Procedure

Vinamold Hot Melt Compounds are a series of castable materials, based on vinyl resins. They are designed for the manufacture of flexible moulds for casting plaster of Paris, cement, wax, thermosetting resins, etc. They have fair tensile strength and are available in grades varying from high flexibility to stiff, but still resilient, compounds, with melting points of 120°C, 150°C, and 170°C.

45. Low relief plaster measuring 3 ft. by 1 ft. 9 in. taken from a Vinamold mould. Grade 2036 (yellow) was used because of its greater rigidity (photo: Vinatex Ltd and Clark & Fenn Ltd)

These compounds are proof against water and many chemicals, and are not affected by climatic conditions; changes in the humidity of the air do not alter their shape, nor do they dry out. Moulds made from Vinamold may be stored for years, and will be found just as good as they were when first made. The finest detail can be reproduced, and in many cases, hundreds of casts made from a mould before it is worn out. The mould may then be **melted down again,** and re-used. The melting points of these compounds are so high, that temperatures up to 80°C will not affect them. This means that phenol-formaldehyde resins can be cured in these moulds up to that temperature.

Moulds from this material will give a faithful reproduction of the model; rough surfaces will reproduce rough, glossy or polished surfaces will leave the mould with exactly the same amount of gloss or polish. Even scratches and blemishes on the master reproduce in the mould, and then in the cast.

All Vinamold grades melt down to an easily pourable liquid, and, since two grades of one group may be mixed, compounds with intermediate flexibilities can be made up.

The following grades, which cover all requirements, are at present available.

Range	Very Hard	Hard	Medium Hard	Soft
LOW MELTING Melting 130-140°C Pouring 120°C (248°F)	2036 (Yellow)		1028 (Red)	
STANDARD 150°C (302°F)	18 (Chocolate)	21 (Buff)	54 (Light Buff)	774 (Blue)
SPECIAL 170°C (338°F)			410 (Brown)	
1 lb of Vinamold — 27½ cubic inches				

Selection of Grade

The selection of the most suitable grade depends largely on the shape and size of the original to be reproduced, but some other points must also be considered, such as the intended type of mould (case-mould, two-piece mould, open mould, etc.), the kind of filling material (plaster, concrete, resin, etc.), whether the filled mould will have to be heated (curing of cast resins), the materials of the master, and which temperature range can be safely handled with existing equipment.

In general, the low melting range is the most suitable for sculpture. Small models with a large number of undercuts, require the softer grades of Vinamold, HMC 1028 (Red) low melting, or HMC 774 and HMC 54 of the standard range; whereas large and compact objects are best made in moulds of HMC 2036 (Yellow) low melting, or HMC 21 and HMC 18 of the standard range. In particular, when a case-mould is employed for a very large object, allowing only from $\frac{1}{2}''$ to $\frac{3}{4}''$ mould thickness, the hardest grades HMC 2036 low melting, or HMC 18 standard, should be employed to avoid any risk of collapse of the mould, even though it may be securely anchored to the case. The best grade or combination of grades for a particular case can only be determined by the user.

Low Melting Range. Two grades of this range are available. HMC 1028 (Red) of medium flexibility, and HMC 2036 (Yellow). Both are easily melted in simple equipment at a temperature of 130-140°C (266-284°F). When the compound has become liquid, the container should be taken away from the source of heat, and the compound allowed to cool, whilst being stirred continuously, until the mass has dropped to 120°C (248°F). It is essential that a thermometer is used, so that the right temperature may easily be determined. Without a thermometer, the right pouring time is found by feeling when the liquid becomes a little stiffer, but without gelling.

It should then be poured fairly quickly and without stopping, into the mould case, until filled to the top. The danger of premature gelling is not very great, as even slightly gelled material will still give excellent reproduction.

The lowering of the temperature of this group of compounds is of rather great importance, as the lower the pouring temperature, the smaller the danger of the development of bubbles on the mould face, caused by expanding air or evaporating water. At the temperature of 120°C, it is also possible to use masters modelled in Vinagel, (*see* p. 109) should it be desired to use this material. This easily worked compound will withstand 120°C and does not require much preparation; coat lightly with Vinagel parting agent, and allow to stand for about twenty minutes before pouring Vinamold.

46. Easing a plaster cast from a small Vinamold mould. Note the flexibility of this material. (photo: Vinatex Ltd)

Vinamold HMC 1028 (Red) is the most suitable compound for the beginner and the hobbyist, but many professional users and industrial users have changed over to this compound, owing to the ease of working. Almost any type of mould can be made from it; however, for moulds requiring a stiffer compound, HMC 2036 (Yellow) may be used. By mixing the two grades in various proportions, intermediate flexibilities can be obtained. For concrete castings, the medium melting Vinamold range HMC 18 and HMC 21 are normally preferred.

Standard Range. The compounds in this group have been on the market since 1947, and have proved excellent for everyday use. Their melting temperature lies at 150°C still sufficiently far enough below the critical temperature, when rapid decomposition begins.

A range of four compounds is available with flexibilities from soft to very hard. HMC 21 (Hard) is generally used for concrete work. Small delicate ornaments are made in moulds from HMC 774, a softer grade. An intermediate grade, HMC 54, is sometimes preferred, owing to its greater tensile strength, combined with good flexibility for general casting purposes. HMC 18 or mixtures of HMC 18 with HMC 21 are useful for large fibrous plaster works, large two-piece moulds, and heavy concrete casts.

Special Grade HMC 410. A compound with a still higher melting point, 170°C (338°F) is now used mainly for epoxy resin casting, and is a non-distorting material, able to withstand prolonged heating cycles for the curing of cast resins. Moulds filled with casting resin may be heated for long periods at the specified temperature without shrinkage or distortion. An interaction between resin and mould does not take place, and the cured casting can be removed from the hot mould. A parting agent is unnecessary. This special grade HMC 410 is more difficult to melt, and requires great care to prevent overheating and decomposition. The danger point lies at 180°C. A mould from HMC 410 is practically indestructible, owing to the high tensile strength, which is far greater than any of the other Vinamolds. It is of medium flexibility, and can be used for plaster and concrete castings where deep undercuts demand a strong and flexible mould.

It should be noted that both HMC 1028 (Red) and HMC 2036 (Yellow) are now normally used for phenol-formaldehyde cast resins, and provide accurate reproduction.

Treatment of the Mould. If the mould should be found faulty, owing to a blemish on the master, or air which has come out of the model it can be repaired by touching up with a hot knife. A tear in the mould can be repaired by the same method. The mould can be washed with water to remove dust or the remains of previous castings; the oily surface makes it unnecessary to treat the mould before filling. At the same time, the oil acts as a protection and helps to retain the high gloss. Soapy water or detergents may be used to clean a mould thoroughly, but as this will also take off the oil film, the mould surface may become dull. Water will, however, never be taken up by the Vinamold, and has no effect on it. Organic solvents should not be used to clean a mould; even if they do not dissolve the compound, they may be taken up in small quantities, causing the mould surface to swell and distort. When Vinamold moulds are fitted in their plaster cases, the inside of the case should be shellacked first, to prevent the plasticiser from being absorbed from the mould.

The Vinamolds do not contain volatile solvents or any ingredient known to be toxic. However, they should not be used in the preparation of food.

Method of Heating and Melting

When Vinamold is heated, it first softens to a jelly-like mass, which can be stirred, but will be stringy, and not show much flow. This takes place at a temperature between 110 and 130°C (230-284°F), according to the range. An increase of temperature will melt the compound to a freely flowing liquid, which is easily poured. The temperature will be found to be in the region of 130-140°C (266-284°F) for the low melting range, and 150-160°C (302-320°F) for the standard range. The special grade HMC 410 requires 170°C (338°F) to liquify. A further increase of temperature has hardly any influence on the fluidity, but will eventually damage the compound by causing decomposition.

The danger point lies at 180°C (356°F), but before this is reached, sufficient warning is given by an excessive amount of fumes emitted from the molten mass. A slight discoloration, particularly with the light coloured grades, does not matter very much, but the appearance of streaks of a distinctly darker colour indicates that decomposition is beginning. As seen from the above-mentioned temperatures, **Vinamold cannot be melted in water, or in a water-jacketed vessel,** since a high enough temperature will not be reached to affect the compound. In all cases, the material should be cut into small pieces before being put

47. Melting small amounts (up to 1 lb.) of Vinamold low-melting grade in an air bath type container (photo: Vinatex Ltd).

into the melting pot and should always be periodically stirred whilst being melted.

Melting Small Quantities. There are several ways of melting Vinamold. The simplest, but least satisfactory, is to heat the compound in a saucepan over the gas or an electric hot-plate. Only

75

small quantities, up to 1 lb. can be safely melted in this way, and the saucepan must be placed on an asbestos mat. Cut the material up into small pieces. At first, only a small quantity should be placed in the pan, and the compound stirred whilst being heated. When the first quantity is beginning to liquify, a further few pieces should be added, stirred, and the lid replaced on the pan for a few minutes. The purpose of this method is that small pieces will melt quickly if dropped into some material which is already liquified; if each small quantity added is allowed to melt individually, there will be less chance of having unmelted lumps in the middle of the mass.

Melting Larger Quantities. Quantities of more than 1 lb. should be melted in jacketed vessels. Cut the material into small pieces, and gradually add them to vessel, stirring periodically. Satisfactory vessels may easily be made from simple arrangements of tins, saucepans, etc. For quantities of 1-10 lb., quick results can be achieved with an air bath, i.e. a glue pot without water, or an arrangement of two tins, one inside the other. For example: with a ½-gallon tin, cut a hole in the lid just large enough to allow an open quart tin to be inserted. Place the tins on a gas ring and put about one inch depth of Vinamold, cut into small pieces, into the inner tin. The air between the two tins will largely prevent overheating, and the necessary temperature will soon be reached over a low flame. The inner container should have a well fitting (not airtight) lid, to prevent excessive fumes from escaping from the melting compound; these fumes carry some of the ingredients, so that it is expedient to keep them in.

Similar devices can be built from larger containers, but if quantities of 5 lb. or more are to be melted, special equipment should be used; this is produced by the makers of Vinamold (Vinatex Limited).

Correct Temperature. The use of a thermometer will greatly assist in obtaining correct temperatures for melting and pouring. Ordinary chemical glass thermometers, with a reading to 200°C (392°F) are easily obtainable at a reasonable price. This type of thermometer is quite strong, and may be used to stir the compound gently. Readings should be taken with the bulb still immersed, but make sure that the thermometer is not touching the side of the vessel.

48. Vinamold Heater. The pan fits into the base forming an air bath. This heater melts about 2½lb of Vinamold at one time.

Pouring—General Remarks. When the compound has reached its correct melting temperature (see page 70 at beginning of the chapter), allow it to cool slightly to the pouring temperature. The compound will not, as a rule, contain air bubbles, since any bubbles mixed in will quickly rise to the surface. Liquid Vinamold can be kept at the correct temperature for several hours if necessary—an important factor if a number of small moulds are to be made from one batch. The source of heat, if not thermostatically controlled, should be turned down just enough to allow

for heat losses, and the temperature checked frequently A lid should be kept on the melting pot.

When pouring, it is important to cast the entire mould in one pouring, without a break. This helps to prevent the trapping of air, and the formation of flow lines on the mould surface.

When cast, it should be allowed to cool slowly, to avoid strains in the mould. Nothing is to be gained by attempting forced cooling with cold water. It is important to allow the mould to cool right down before the model is removed. If the mould has to be cut, a sharp knife, jelly knife, razor blade, or serrated knife may be used. The cut surfaces should be well dusted with French chalk to help correct registering.

Chapter 8

Vinamold—Making a Flexible Mould

A model of almost any rigid material may be used, provided it does not soften at the melting point of the compound. Metal objects are used without any preparation; however, if they have a coat of paint, this will have to be removed, since most paints are softened by hot Vinamold. Other non-porous materials, such as glass, china or glazed pottery, are also very suitable, but they must be carefully heated to prevent a cold surface from cracking on contact with the hot compound.

Porous Materials. Porous materials, such as plaster of Paris, cement, etc., must be treated to prevent trapped air from escaping and marring the mould by forming bubbles. Surface coats of ordinary lacquers or shellac are useless, for three reasons. The hot compound will melt these coatings, and make trapped air expand—the air in the surface must be displaced, not covered. Secondly, when the Vinamold melts, or attacks, the lacquer, or shellac, etc., it leaves a non-drying tacky surface on mould and model. Thirdly, these coatings over the model will cover any fine detail, and so prevent the highly sensitive material from reproducing it.

Several methods have been found to give satisfactory sealing effects. Large plaster models can be used water-wet. Water will have filled the pores, and, provided the model is of some bulk, will not be heated to boiling point by the hot compound; the cold bulk of the model will prevent the surface from overheating. Smaller models may absorb so much heat, that steam bubbles form; this method is not recommended in such cases.

Impregnation with shellac, cellulose lacquer or solutions of thermo-plastic resins has been found useful; but the impregnation must be well dried out, leaving no traces on the surface of the model. Sealing with shellac solution (20-30 parts of shellac and 100 parts of methylated spirits) is specifically recommended for

use with the low melting grades HMC 1028 (Red), and HMC 2036 (Yellow). This solution will penetrate the pores of the model, and displace the air. If a mere surface coat is put on, the air, still retained in the pores, will break through when it expands under the influence of the hot Vinamold, and will cause a faulty mould. After the impregnation by immersion in the shellac solution, the surface should be cleaned with a little methylated spirits and the model left to dry, first in air for twenty-four hours, and then, if possible, by warming in an oven at a temperature up to 80°C until completely dry, and will be ready when it is no longer possible to detect a solvent smell. The model may still contain unfilled pores, which will cause bubbling in the mould when the material is poured around the model, and a final treatment with Vinamold Sealing Oil is recommended. The object should be immersed into the sealing oil. Small objects will require 20-30 minutes; larger objects correspondingly longer. The object should then be taken out, and left to drain. Any surplus oil is wiped off the surface of the master, which is then ready for moulding.

When a heating cabinet is available, it will improve the quality of the mould if the sealed object is warmed for a short while; it will be noticed that a further excess of oil will exude. This again is wiped off—the warm master is now ready for moulding. (The temperature in this case should not be higher than 50-60°C.)

A very effective seal is easily obtained on porous objects by painting with three thin coats of shellac, three thin coats of metallic aluminium paint, and one further thin coat of shellac. Each coat should be allowed to dry before the application of the next.

Clay models should be moulded before they become hard. The clay needs to be still quite soft, not wet, but not yet leather hard. No preparation of the surface is needed at all.

Wooden Objects. Wood is the most difficult material to use as a master, and faultless moulds cannot always be guaranteed. The natural moisture in wood (about 16%), together with the air contained in the pores, will be found troublesome. As wood is less porous than plaster, sealing media will not be absorbed so readily. Drying improves porosity, but the risk of cracking must be considered, especially in the case of carved objects. A safe way to

make a Vinamold mould of a wooden object, is first to make a plaster cast (using a gelatine mould), and to use the plaster as a master—treating it with aluminium paint and shellac.

There are two other ways of treating wooden masters. One is to use a polyester resin gel coat; a coating of catalysed resin being brushed over the whole object. The second, is to use a synthetic resin, Furane Cast-cote No. 672.

Cement. Cement, or cast stone objects, which are usually large (such as garden ornaments), are best used water-wet. Soak for several hours, dry superficially, and use as masters without any further preparation.

Ivory. Ivory objects may also be used as masters. However, in the case of antique ivory, which is generally porous, a plaster master should be used, made by the gelatine method (as with wooden objects).

Masters of Plastic Materials. Many articles from which reproductions are required are made from one or other of the various plastic materials available. The methods for taking moulds, therefore, vary accordingly.

Objects made from **thermo-plastic compounds,** such as celluloid, cellulose acetate, polystyrene, polymethyl methacrylate, polyethylene, etc., will not stand the heat of melted Vinamold, and cannot be used as masters. A plaster reproduction should be made first, by means of a gelatine mould, and treated with Vinalak, as described above. Where there is no undercutting, certain dental impression or duplicating compounds can also be used; they will give well-defined moulds from which one or two faultless plaster casts can be taken. Such casts should be sealed, and coated with Vinamold sealing oil, before moulds are taken.

Thermo-setting plastic materials, such as 'Bakelite', generally contain small amounts of moisture, and should be dried at a temperature not exceeding 105°C (221°F). As soon as they have cooled down, Vinamold sealing oil should be applied, and a mould taken in the usual way.

Mould Cases

The mould must be poured in some form of container or case, to contain the liquid Vinamold round the model until it has set. After cooling, remove the whole from the case or container, and withdraw the model from the mould. Where there are large undercuts, or where the model is much wider than its base, it may be difficult or even impossible to withdraw the model, without damaging the mould. In such cases, cut the mould open at one side until the object can be removed easily. Where possible, cut the mould with a jelly knife, so that a good keyway is left; this will ensure that when the mould is assembled for casting, it will be perfectly registered. The cut edges should be dusted with French chalk so that they will slide easily into the correct positions. There are two types of moulds: those which are squat and small, which require no case, being poured in a container, and those which are poured in a case.

Containers. Although moulds for objects which are small and squat do not need a case, a container must be made for pouring the mould (see plates 49, 50 and 51). The container should have sufficient space between itself and the model, both to allow the hot mix to pour freely, and to ensure that the mould is sufficiently strong to stand firmly by itself. It may be a tin, saucepan, or any other existing vessel, or can be simply made up from a thin metal strip coiled and tied with string to form a cylinder round the model.

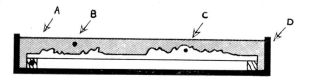

*Fig. 49 Shaded area represents poured Vinamold
(A. ½″ wood strip; B. Vinamold; C. master; D. outer box)*

The base may be a metal plate, slab of stone or clay, etc.; a seal between the wall is obtained by sealing with wet clay or 'Plasticine', or adhesive paper. A still simpler way to make a container, is to use stout paper, cartridge paper, thin cardboard, etc., and build a vessel of the most suitable shape, according to the model. Paper will not adhere to Vinamold, but a thin brushing with oil

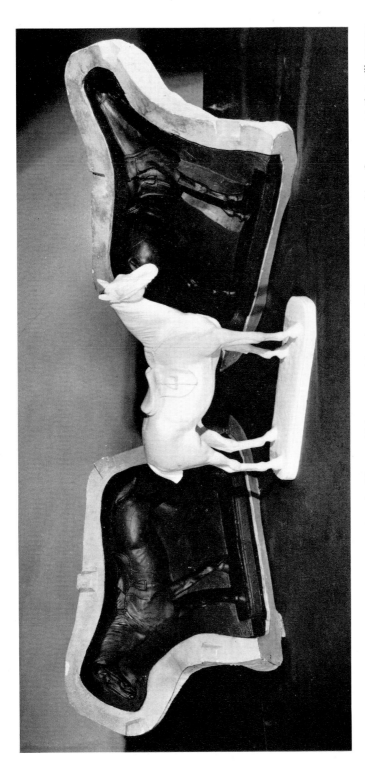

50. A Vinamold two-piece mould with cast from it. The mould is supported by plaster half-cases which provide a firm support that will prevent the mould from sagging out of shape when the plaster is being poured (photo: Vinatex Ltd).

or a dextrine glue will facilitate later removal, though this is not essential.

But, like any heated material, it shrinks a little on cooling, and it will be found that a mould as described will show a saucer-shaped cavity on the surface. If this surface is required flat, so as to serve as a base later on, the cavity should be filled with a further small quantity of hot mix as soon as it appears in the cooling mould. If this is done **before** the mould is cold, the two pourings will join together, and the shrinkage of the second will not be noticeable when the mould has cooled down completely. It has been found beneficial to cover the top of the filled mould case, to prevent too rapid chilling of the surface.

In every case, sufficient time must be allowed for the mould to set completely. A few pounds of the compound will require several hours to cool, and although the surface may be cold to the touch, the inside may still be very soft and lose its shape if disturbed. It is safest to leave a newly-cast mould to cool **overnight** before removing the master.

Case-Moulds. Caseless moulds are wasteful where large objects are concerned, and a proper plaster case should be made to receive the Vinamold (see plate 50). In fact, this type of mould is made in exactly the same way as a gelatine mould. Full details of gelatine moulding are given in the book by Victor Wager *Plaster Casting for the Student Sculptor*. The gap between model and case should, however, be larger, $\frac{3}{8}''$ to $\frac{3}{4}''$, to avoid restricting the flow of the hot-mix during the pouring operation. The cases, which are generally made of plaster reinforced with hessian scrim, should be given a dressing of shellac, which will not, in this instance, be harmful. Sufficient air vents should be provided to allow the escape of air, and large funnels used to ensure sufficient head when pouring.

Two-Piece Vinamold Moulds. Where a two-piece mould is requisite (see plate 50) this is poured in the same way as two-piece gelatine moulds. One half of the model is covered with a clay blanket the thickness of the proposed half mould, and a supporting plaster half case built over it. Turn the lot over and repeat. Then remove one of the half blankets of clay and fill up the space left between the model and half case, with Vinamold by pouring this through a hole made in the case. Allow to cool,

84

turn over and repeat. Before starting on the second plaster half case and the second Vinamold half mould, treat the edges to prevent their sticking; using shellac on the plaster edges and French chalk on the Vinamold edges.

Suitable Anchors or Recesses should be provided in the mould case to keep the mould in position. The choice of the right type of Vinamold is of great importance, and the hardest grade compatible with other factors, such as shape and undercuts of the model, should be employed. Moulds made of more than two pieces are treated in exactly the same manner, but in general the selection of the correct grade from the range available will enable the work to be done in a mould of not more than two pieces. Remember, that a Vinamold mould should not be left in a plaster case for too long a period unless the plaster has been shellacked first; the porous plaster would otherwise tend to extract the plasticiser from the material, causing brittleness, and possibly some shrinkage of the mould.

Pouring

It is absolutely essential that the hot mix should **not flow downward** over the master, but be made to rise from the bottom upwards. When using a container, pour the liquid against the container's side (see plate 51). Where a case is being used, it will have to be designed accordingly. With narrow but high objects, such as figures, etc., the pouring should be done either down the side of the case, or through a funnel and tube entering the case near the bottom. Extend the vent hole on the top of the case upwards by means of an escape funnel or riser; this will give sufficient head for pouring.

Once pouring has commenced, there should be no interruption of the flow until the Vinamold stands, in the funnel, at least six inches over the highest point of the master. Gates, runners and risers should be removed after the mould has cooled, and returned to the melting pot. Very long flat objects, such as cornices, are generally of the case-mould type, although they are sometimes made as an open mould.

51. Pouring a small quantity of low-melting Vinamold. Note that the liquid Vinamold is never poured over the object but round it or against the sides of the casing. This avoids trapping air bubbles (photo: Vinatex Ltd).

In very long and tall casts, where there is clay, or where the plaster model has been soaked before assembly of the mould, the hot mix if poured through one funnel only, may be found to cool too much before reaching the far end, failing to fill fine detail sharply, or entrapping air. In such instances, the mould case should be provided with a number of funnels, about 2' 6" apart; pouring should be done by following up as soon as the hot mix from the preceding funnel appears under the next.

Strengthening Ribs or Members. These can be incorporated by embedding them in the mould, an important factor in the manufacture of fibrous plaster casts, where plaster and reinforcing materials are pushed in by hand, and where a dislocation of the mould might lead to distorted casts. The properties and characteristics of the different types of Vinamold available have been described in the introduction to this chapter, and it has already been said that a successful mould depends very often on the right choice of grade. Owing to the multitude of shapes and sizes,

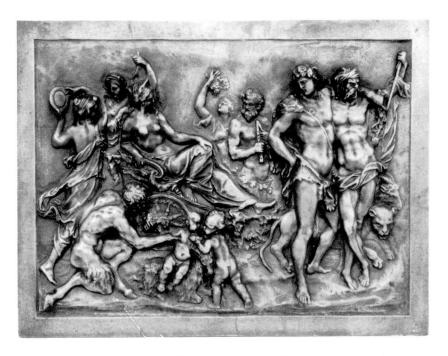

52. A metal plaque measuring 16″ x 12″ from which a Vinamold mould is to be made: The only preparation for a metal plaque such as this is cleaning the surface, then gluing a wooden strip ½ in. x ½ in. along the underside edges of plaque (see diagram 49, page 82). A case is then made ½ in. wider all round. The plaque is then placed into position prior to the pouring of the molten Vinamold. Note: If suitable preparation is made, an ornamented picture frame can be cast integrally with the plaque which, in the mould, can be cast in a contrasting metal. (photo: H. M. Percy)

indications only can be given on the correct grade for any particular model. A mixture of two grades (within the same range) may be made in any proportions, and the intermediate flexibilities thus obtained may produce the perfect mould.

Before pouring, the mould should be assembed, and properly secured. Where the mould has been poured in a container (i.e., caseless), tie securely with string or rubber band.

Casting Materials

Cement and Concrete Casting. The manufacture of concrete castings for ornamental purposes has become an economical pro-

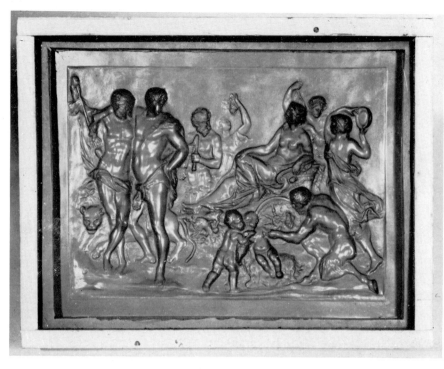

53. The finished Vinamold mould in its case which now acts as its support. The raised edge all round the outside edge of the case is fitted so as to hold the liquid metallic mix when pouring the metal gel coat (photo: H. M. Percy)

position with the advent of flexible Vinamolds. The harder grade HMC 18 and HMC 21 are recommended; many castings can be taken from such moulds before they become worn, and require re-making. The advantage of a Vinamold mould over a rigid plaster mould, consisting of many pieces, or over rubber moulds which cannot be recovered, is obvious. The castings may be removed after twenty-four hours, as against forty-eight hours from a steel mould, thus doubling the output. About 200 casts can be taken from a mould before remelting becomes necessary.

Cast Resins. Reference to the phenol-formaldehyde casting resins has already been made. Grade HMC 1028 is recommended and will stand up to the curing temperatures of 50-80°C. The cured castings can be taken out of the hot mould which may be filled again immediately, thus saving cooling and reheating time.

88

54. Corinthian capital in plaster, about 3 ft. 6 in. x 3 ft. This cast and the Vina-mold mould for it, were made by Thomas and Wilson Ltd (photo: Vinatex Ltd).

Vinamolds, as has been mentioned earlier, have not been specifi-cally designed for polyester resins catalysed in liquid form, but it has been found, through experience, that filled (i.e. loaded) poly-ester resins, either with metal or inert powder fillers, perform satisfactorily. A number of casts may be taken from these moulds, but if the resin is used without a filler, it is possible that only one or two casts will be taken out.

Plaster. As already mentioned, complete information on the handling of plaster is obtainable from *Plaster Casting for the Student Sculptor* by Victor Wager. Hundreds of plaster casts may be taken from Vinamold moulds.

55. A Vinamold mould made from grade 2036 (yellow) of a large ceiling rose measuring 2 ft. 6 in, in diameter (see plates 8 and 9) (photo: A. Tiranti Ltd)

Finishing Materials for Plaster

Vinamold Plaster Hardener SP.12. This is a new plaster hardener, which has been developed to improve a number of properties of plaster. It is based on an aqueous dispersion of synthetic resin; it is miscible with water in all proportions, and extremely simple to use. Its advantages are:

(a) The strength and scratch resistance of the plaster is increased considerably.

(b) Paint can be applied almost immediately, without any previous preparation, such as sizing, etc.

56. Plaster cast of a wall panel 5 ft. x 3 ft. from a Vinamold mould (photo: Vinatex Ltd)

(c) The resilience of the plaster is increased, thereby reducing considerably the number of breakages.

(d) Surface defects, such as bubbles in the cast, are practically eliminated.

(e) The surface and feel of the plaster is improved.

SP.12 should be diluted with water in the proportions of 1 part of SP.12 to 4-6 parts of water by volume. Stirring should not be vigorous, otherwise the mixture may foam excessively; slight foaming, however, is not harmful. The diluted SP.12 settles on standing for a period, and should therefore be stirred before use. Vinamold plaster hardener SP.12 is non-toxic and non-inflammable. It is slightly corrosive to iron and mild steel, and should be stored in polythene, glass, stainless steel, or lined metal containers. When SP.12 is not in use, it should be kept airtight.

Glazing Lacquer : Vinaglaze SP.20. A clear finishing lacquer for plain and decorated plaster articles. It is based on a polystyrene solution in Xylol, and plasticised to combine hardness with sufficient flexibility to impart a deep china-like glaze with excellent mechanical strength to the article to which it has been applied. Coats of these polystyrene lacquers have the property of outstanding durability, they are water clear, and will not discolour with age. Vinaglaze is not liable to crazing.

Vinaglaze may be brushed, sprayed, or used for dipping, and is thinned with one of two thinners—S.11 for brushing or dipping, or S.30 for spraying. The lacquer will not affect water or poster paints, nor disturb cellulose paints. Vinaglaze is supplied in transparent form, but it may be tinted by the addition of oil soluble dyes, or pigmented.

Chapter 9

Matched Die Moulding with Vinamold

A new technique in the use of Vinamold has been developed by Mr. J. Hake of Carter Panels Ltd., of Poole. This is a really economical method of matched die making, which enables a glass fibre reinforced polyester resin laminate to be made with a smooth surface on **both sides** of the laminate.

This new technique utilises the unique properties of Vinamold, which being elastic, and at the same time non-compressible, ensures that when pressure is exerted on one surface, this pressure will be transmitted equally to all the other surfaces. The female mould is made from a rigid material, such as a hardwood, and the core is made from Vinamold. The material to be moulded, the glass fibre resin laminate, is laid in its uncured state over the Vinamold core, which is then placed in the rigid mould. Pressure is exerted on the uncoated top of the flexible core, causing it to expand in all directions, forcing the laminate mix against the rigid mould walls, where it is left compressed until completely cured. In this way, a moulding is produced, comparable in quality to one produced from matched die metal moulds.

In industry, the normal method of producing glass fibre laminated shapes, involves metal male and female moulds. Such moulds are very expensive and time consuming to produce. Although long runs are assured from matched die moulds, this advantage is of no interest to the sculptor and designer. However, there may be times when a small number of casts is required, with a good finish on both sides, and the new Vinamold matched die mould technique should be of great assistance in this respect.

Reference to the illustrations on these pages will indicate the stage by stage build up. As the pressures involved are comparatively low, hardwood is quite suitable as a material from which to make the female mould. the process is most suitable for mouldings which are open on one side (i.e. boxes, containers, covers, or even curved panels). In such cases, the Vinamold core is made so that the uppermost surface lies at the same level as the top edge of the outer mould. Both parts of the mould are covered by a strong piece of wood, which can be pressed against the mould by means of a toggle or 'G' clamp. In order

to exert the required amount of pressure on the elastic Vinamold core, a flat piece of wood is fitted to the underside of the pressure board, its size roughly corresponding to the amount of Vinamold which must be displaced to force the glass fibre resin mix fully against the mould face.

1. The Female Mould. The female mould should be made from hardwood in two or more pieces, according to the complexity of the article. The mould pieces can be locked together, to form the mould cavity, by means of bolts and wing nuts.

The inner surface of the enclosed mould represents the outer contours of the laminate to be made.

2. The Vinamold Core. For articles where the wall thickness will not exceed $\frac{1}{8}''$, the Vinamold, heated to a liquid (see chapter 7) is simply poured into the mould cavity to form a solid block. Preparation of the wood prior to pouring the hot Vinamold consists only of warming it slightly. Pouring should be carried out very slowly in one continuous operation, and at one end of the mould cavity. After cooling, which takes several hours, ease the Vinamold core from the mould cavity. It will be noted that the dimensions of this block are those of the outside of the article to be produced—this is of no disadvantage when simple shaped articles are to be moulded.

Where a wall thickness of **more** than $\frac{1}{8}''$ is required for the finished article, a slightly different core making technique is used. The wooden mould is lined with strips of some material of roughly the thickness of the final article. For flat surfaces, metal strips in aluminium are most suitable; for round or intricate parts, sheets of lead, pure tin, or a special wax* can be used. After lining the mould, the cavity roughly corresponds with the internal size of the intended article. The Vinamold core is now poured as described above. When cooled down, remove the core, and cut off any flashings which may have been caused by seepage through the lining material. Remove the lining material from the mould.

3. Treating the Mould Surface. The surface of the mould should now be prepared in the usual way for use with polyester resin (see Chapter 3, Section B).

*Master Sheet Wax H.T. 260 made by Astor Boisselier & Lawrence, 9 Savoy Street, Strand, London, W.C.2.

57. Vinamold core being lifted from mould after cooling. The inside of the wooden mould is then well polished with Johnson's wax.

58. The Vinamold core carrying the laminate is replaced in the open mould.

59. The intensifier top plate is applied and screwed with a 'G' clamp.

60. The cured laminate being removed from the flexible core. (photos: Vinatex Ltd.).

The under parts of the pressure plate, and the top edges of the mould should also be well treated with parting agent.

4. Laminating on the Vinamold Core. Before the core is used for the first time, make up a gel coat mixture of polyester resin, and mix in an additional 1% of accelerator before adding the usual 1% of hardener. Paint this mix onto the core, and allow it to cure. When hard, remove the resin shell and throw it away. The Vinamold core is now ready for use, and the above treatment will give a tack free surface on the laminate.

Using a laminating mix (9 parts laminating resin to 1 part thixotropic

95

paste resin), laminate over the Vinamold core with chopped strand mat or glass cloth, until the required thickness is reached. Make sure that the core is evenly covered, and remember to keep clear of the top of the core where the pressure plate will be placed.

5. Inserting the Laminated Core in the Mould. Place the laminated core into the open mould, and close it up; but before tightening by means of wing nuts, thin strips of metal are inserted over the open joints in order to avoid pinching the glass reinforcement in the opening. The metal strips are removed from the joints now closed.

6. Applying Pressure and Curing. The top compression plate is now placed on top of the Vinamold core, and clamped down by means of toggles or 'G' clamps. The flat piece of wood under the pressure board will start to exert pressure onto the core, which in turn will transmit the pressure to the bottom and sides, compressing the glass fibre laminate tightly against the wooden mould. Any trapped air and surplus resin will be forced out. The top pressure plate should be tightened down tightly onto the upper edges of the sides of the wooden mould, in order to prevent the Vinamold from riding up the sides of the lower pressure piece. The laminate should be left under pressure until it has cured.

7. Removal from the Mould. After curing, open the mould, and withdraw the laminate from the core. The trimming operation is aided by markings on the mould, which are reproduced in the laminate. This will enable the moulding to be easily trimmed without expensive jigs.

The Vinamold core is not affected by repeated mouldings and the pressing operation. When the core is no longer required, it can be cut up and re-used.

Chapter 10

Silicone Rubber Moulds—Cold-Cure Silastomer

Silicone Rubber is a comparatively new, and highly interesting flexible moulding compound. The type dealt with here is called Cold-Cure Silastomer, manufactured by Midland Silicones Limited.

Cold-Cure Silastomer is a white compound, manufactured in three grades:

9161—pourable
9160—spreadable like butter
9159—consistency of builders' putty

All three grades of Cold-Cure Silastomer change into silicone rubber at room temperature simply by the addition of the Catalyst N9162. This chapter will only deal with the fluid grade (9161) and the medium grade (9160), since the third grade is not practical for sculptors and artists to use.

When Cold-Cure Silastomer has cured at room temperature, it becomes a white, flexible rubber; it reproduces the most intricate detail, and takes plenty of undercut. This material will be of great use to sculptors and Museums, especially when used for casting polyester resins.

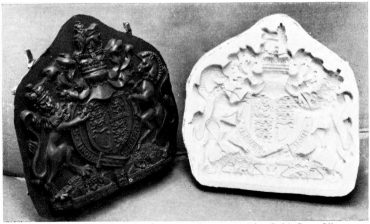

61. A glass fibre reinforced polyester resin cast, and its Cold-Cure Silastomer mould (photo: Midland Silicones Ltd. & Pytram Ltd.).

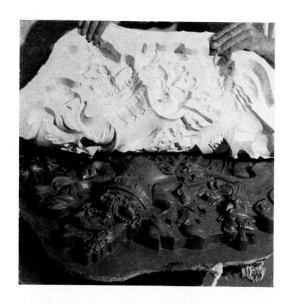

62. The mould being removed from the cast in plate 61 (photo : Midland Silicones Ltd. & Pytram Ltd.).

63. Medieval wax seal and its Cold-Cure Silastomer mould (photo: Midland Silicones Ltd.)

Advantages of Cold-Cure Silastomer. In many respects Cold-Cure Silastomer is an ideal flexible mould making material. It is

extremely easy to use—just mix and pour—and setting time can be controlled from minutes to hours. Cold-Cure Silastomer cures at room temperature, and because of this it may be used on valuable and delicate originals without any harm (see the illustration of a Mediaeval wax seal), and it will not harm painted objects. It reproduces the finest detail, and may, therefore, be used on intricate castings. Flexible Cold-Cure Silastomer moulds will normally reproduce a very large number of castings, even using polyester resins, which have no damaging effect on them. Moulds will store indefinitely, because they are resistant to moisture, and will not oxidise or deteriorate in any way.

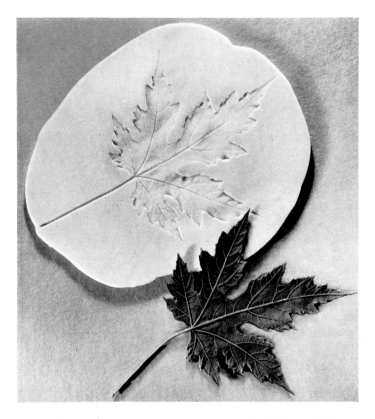

64. Cold-Cure Silastomer mould made from a leaf (photo: Midland Silicones Ltd.).

Disadvantages of Cold-Cure Silastomer. There are only two disadvantages in using this product, but it is only fair to point them out.

The initial cost is high (in small quantities over thirty shillings per pound, which is about $\frac{2}{3}$ pint), although this is normally absorbed over many casts. The only other disadvantage is that over the first period of six to eight months, there is a very small amount of shrinkage. However, in spite of these, Cold-Cure Silastomer has so many good points that it is already in wide use in the sculpture world, particularly in connection with polyester resins.

Preparation of the Master Surfaces. Since the slightest imperfection on a master is reproduced—even dust—it is vital to ensure that the surface to be reproduced in Silastomer is thoroughly clean, and that no oil or grease is present to affect the curing. All corners and crevices should be completely free from dust and foreign matter. In the case of masters with much intricate detail and undercut, a liquid detergent solution (5 parts in 100 parts of water) should be sprayed or brushed onto the surface, or alternatively the master dipped into the solution; allow the master to dry thoroughly. This treatment is not absolutely necessary, but it does help to make release easier.

In cold weather, it is advisable to ensure that the master is slightly warmed before the actual moulding operation begins, so that the curing cycle is not retarded. No other preparation is necessary.

Types of Moulds. There are four basic types of mould—one piece, two piece, open and reinforced. In the interests of economy and flexibility, the aim should be to limit wall thickness of the mould to a maximum of $\frac{1}{2}''$ and a minimum of $\frac{1}{4}''$. To achieve these limits, it is necessary to make a mould by various methods, according to the job in hand. In each case, it is advisable to have a rigid casing for the completed Silastomer mould, to hold it in its true shape. In some instances, where a container has been used as a retaining wall for pouring the rubber, it can afterwards be used as the mould case.

Mixing Cold-Cure Silastomer and Catalyst N9162. The conversion of Cold-Cure Silastomer into a rubber-like product is effected by the addition of Catalyst N9162. The time taken to reach a rubber-like state when it can be handled can be as little as 10 minutes, depending solely on the amount of catalyst added and the room temperature. For most applications, 2% of catalyst by weight is sufficient, and this will give a pot life in the case of Cold-Cure Silastomer 9161 of about 70 minutes; (pot life is the working time, after which the catalysed

material cannot be poured or shaped). The pot life of Cold-Cure Silastomer 9160 and 9161 varies:

Typical Pot Life at 20°C (68°F)

% by weight of N9162 added to the rubber	Pot Life of Cold-Cure Silastomer 9160	9161
1·0	35 min	4 hours
1·5	30 min	2½ hours
2·0	25 min	70 min
3·0	20 min	35 min
4·0	15 min	25 min

The curing time (time required for the set material to develop its optimum properties) can be reduced by raising the temperature and/ or the percentage of Catalyst N9162. The thickness of mould section also affects the curing time, but 24 hours at room temperature is generally found to be satisfactory.

The catalyst may be effectively dispersed by simple hand or mechanical stirring, but care should be taken to avoid trapping excessive amounts of air in the mix. A clean paper cup, tin, glass jar or plastic container may be used for the mixing operation. Always stir the rubber in its original tin before pouring any off into the mixing pot. Measure out the catalyst either by weighing, or else by volume using a burette or pipette. Although the specific gravity of N9162 is 1·08, for small quantities it is sufficient to take this as 1·0 and to equate millilitres with grams (1 oz is approximately 28 grams).

It may be found useful to add dye to the catalyst, so that it acts as an indicator showing when the catalyst is completely dispersed in the rubber; this will be when the whole mix is an even colour and free from streaks. The following dyes have been found satisfactory in use:

Waxolene Yellow or *from* I.C.I. Dyestuffs Division
Purple P.O. Box 42, Hexagon House,
 Blackley, Manchester 9
Fast Red *from* L. B. Holliday & Co. Ltd.,
 Beighton,
 Huddersfield, Yorks.

However, it should be noted that the total amount of dye should not exceed 1% by weight.

Moulding Very Small Masters. The base of the master should be in full contact with a completely flat surface, to avoid the possibility of any mix creeping underneath during the pouring stage—Plasticine is most useful in this respect. Depending on the height of the master, build a retaining wall either of Plasticine, or of stiff paper fixed by a Plasticine runner, so that it is about $\frac{1}{2}''$ higher. In the case of small

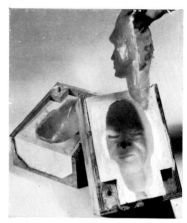

65 & 66 A two-piece Cold-Cure Silastomer mould. In plate 66 a glass fibre cast is being taken from the mould (photos: AP Films Ltd. & Midland Silicones Ltd.).

figures, tin plate, or a plywood box can be constructed around the master allowing for a mould wall thickness never less than $\frac{1}{4}''$.

Prepare a mixture of Cold-Cure Silastomer 9161 and Catalyst N9162 (normally 2%), as already described above, and pour it slowly into a corner of the mould container. Allow the mixture to flow around the master; this will reduce to a minimum the possibility of trapping air. Continue pouring until the top of the master is covered by at least $\frac{1}{4}''$. Allow the mix to set and cure; if 2% catalyst has been used, the mould can be handled after six hours, but the cure is not complete for about twenty four hours, and the mould should not be used until after this period.

Large Masters—Reinforced Moulds. Reinforced moulds are necessary with large masters, both for strength and to avoid using excessive amounts of material. Where undercuts are not too great, and it is possible to make a large one piece mould, the following technique should be followed, using a blend of Cold-Cure Silastomer

9160 and 9161, with stockinette or open weave glass fibre fabric rein-
forcement.

Cut the fabric to size, sufficient to cover the mould. The material has
to be primed in order that the Cold-Cure Silastomer will thoroughly
bond with it. Primer MS 602 should be diluted with acetone to the
proportion of 1 part Primer and 9 parts acetone, and the mixture
brushed onto the material. The coated material should be put aside to
dry for approximately $\frac{1}{2}$ to 2 hours.

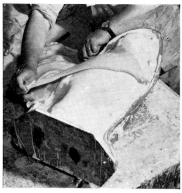 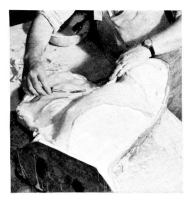

67 & 68 After the first application of Cold-Cure Silastomer, the reinforcing
cloth, treated with priming agent, is placed into position and gently pressed into
the gelled rubber (photos: Pytram Ltd., Courage & Barclay Ltd. & Midland
Silicones Ltd.).

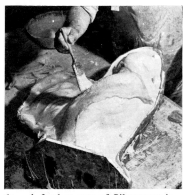 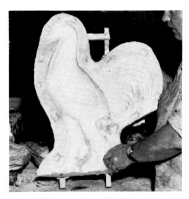

69. A further coat of Silastomer is 70. The completed half mould with
brushed into the fabric. its case.

(Photos: Pytram Ltd., Courage & Barclay Ltd., Midland Silicones Ltd.)

A mixture should now be made up of Cold-Cure Silastomer 9160 and
9161 in the proportion 25:75 parts by weight. Mix the two grades

together thoroughly, before adding 2% of Catalyst N9162. Pour and
spread the mix over the master so that it forms a thin covering over
the whole model, and wait for the mix to gel (not cure completely).
When the mix has gelled, take the primed fabric, carefully drape it
over the coated master and gently press it into the gelled rubber.
Make up another mix of Cold-Cure Silastomer 9160 and 9161 as before,
and this time mix in 4% of Catalyst N9162, and paint over the fabric.
Depending on the shape and size of the master, further reinforcing

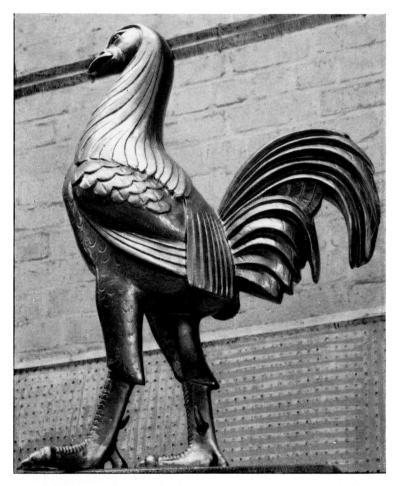

71. Finished cast of the Courage Cockerel, made in glass fibre reinforced poly-
ester resin from the mould in plates 67-70 (photo: Pytram Ltd., Courage &
Barclay Ltd., Midland Silicones Ltd.).

may, or may not, be necessary. If further reinforcement is required, then the procedure should be repeated. In order to ensure that the Silicone Rubber mould possesses the maximum strength, a final layer of 50:50 Cold-Cure Silastomer 9160 and 9161 should be made up, catalysed with 4% of N9162, and applied over the top. Once the rubber has fully cured, a plaster case may be made in the usual way to keep the mould rigid in its proper shape.

Two Piece Moulds. In some cases, it may be necessary to make two piece moulds, depending on the shape of the master. There are two ways of making such moulds. The first is best suited for small three dimensional objects with pronounced undercuts, and the second for large, thin wall and cavity mouldings.

Two Piece Moulds—Method 1. The model is masked by embedding it up to its half way line in Plasticine. Place the embedded master in a container (or build a wall round it), leaving a $\frac{1}{4}''$ to $\frac{1}{2}''$ clearance all round. Now make some indentations in the Plasticine, between the master and the wall; this will reproduce as raised toggles on the top

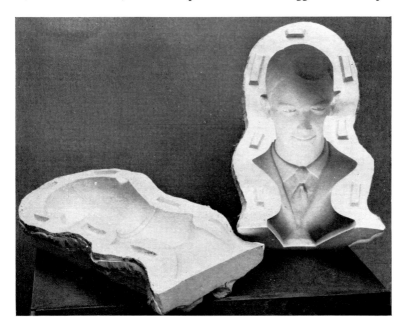

72. A two-piece Silicone Rubber mould—note the toggles (photo: Pytram Ltd. & Midland Silicones Ltd.).

half of the mould for subsequent correct registration of the two halves. Make up a mixture of Cold-Cure Silastomer 9161 and 2% Catalyst N9162, and pour over the model until a level is reached between $\frac{1}{4}''$ and $\frac{1}{2}''$ above the top. When the rubber has set and cured, strip it away from the master, and remove the master from the Plasticine. Replace the Silastomer half mould on the master, and replace it in the container, with the second half of the master face up. Coat the exposed part of the mould with talc or petroleum jelly, to prevent adhesion when the second mix of rubber is poured. Make up another mix of Cold-Cure Silastomer 9161 and Catalyst N9162, and pour into the container as before. Allow to cure for 24 hours.

The cured mould will have male and female toggles, so that the two halves will always close in exactly the same position. A pouring hole and a vent should be cut where appropriate, and a plaster case made if necessary.

Two Piece Moulds—Method 2. This method is for large two piece moulds, and for thin wall moulds of the open type, such as bowls. In principle, it is very much like Method 1, except that the rubber is reinforced with fabric, and each half mould is plaster cased immediately on curing.

Preparations are made for pouring in exactly the same way as for Method 1, remembering to make the indentations to produce toggles. Now make the top half of the mould in exactly the same way as for the reinforced moulds, using primed fabric and a blend of Cold-Cure Silastomer 9160 and 9161, catalysed with N9162. When cured, a plaster case must be made for this half mould, before the second half of the mould can be made. The plaster case should be made in such a way that it will stand level when turned over.

When the plaster case is ready for handling, remove from the mould, and make the usual toggle indentations in the edges. Replace the half mould in the plaster case followed by the master correctly positioned in the mould (the Plasticine having been removed). Re-erect the Plasticine fence, this time on the edge of the plaster case. Coat the exposed edge of the mould with talc or petroleum jelly. Make the second half of the Cold-Cure Silastomer mould in the same way as the first. When it has cured, make the second half of the plaster case in the usual way. Pouring holes and vents can either be cut in the mould when it has cured, or they can be moulded at the time of pouring the rubber by attaching Plasticine rolls or shapes to the master.

106

Making Duplicate Masters of Cold-Cure Silastomer. There may occasionally arise the need to make accurate copies of masters. These are very simply made, using the techniques described earlier in this chapter, by first making a mould in Cold-Cure Silastomer, and then taking a Silicone Rubber cast from the rubber mould. A release agent must be used, in this case—good results have been obtained by using talc or petroleum jelly. The resultant Cold-Cure Silastomer cast provides an exact, yet flexible original which can be treated as an original from which moulds can be taken in plaster or other materials. This is extremely useful, for example, to Museums, who may wish to sell duplicates of certain works in quantity, and do not wish to take repeat moulds from the original. In such cases, the repeat moulds can be taken from the Cold-Cure Silastomer copy of the original.

Low Temperature Metal Casting. Low and medium melting point alloy metals can be successfully cast in Cold-Cure Silastomer moulds. In such cases, it is advisable to heat condition the mould for several hours at a temperature at least 10°C higher than the temperature of the material being cast, but not higher than 250°C. This post cure should only be carried out after the mould has completed the recommended room temperature cure. Dusting the mould with micronised mica prior to casting, facilitates release, and improves the surface of the casting. (Micronised mica is available from Micafine Ltd., Raynesway, Derby.)

Repairing a Damaged Cold-Cure Silastomer Mould. When moulds are cracked or split, the damaged edges should first be cleaned with acetone. Apply some Silicone Rubber Adhesive (Silastic RTV 732 made by Midland Silicones Ltd. is recommended) and put the damaged pieces together.

Handling Precautions. The precautions to be used in handling Catalyst N9162 should be similar to those applied to the handling of organic hydrocarbon solvents such as xylene. That is, the area in which they are used should be well ventilated, and contact with the skin should be avoided as much as possible. Catalyst N9162 contains a silicate and an organo-tin compound which might possibly cause dermatitis in susceptible people. In order, as an extra precaution, to avoid predisposing skin-sensitive people to dermatitis, skin splashes should be washed first with alcohol, and then with soap and water. The silicate

component can be easily detected in the atmosphere at safe concentrations by odour or by an irritation of the eyes. If Cold-Cure Silastomer catalysed with N9162 is to be oven-cured, reference should first be made to Midland Silicones Ltd. Catalyst N9162 is inflammable.

Storage of Cold-Cure Silastomer and Catalyst N9162. Both Cold-Cure Silastomer and Catalyst N1969 should be stored in a dark cool place in temperatures below 25°C. The catalyst is very easily hydrolised by atmosphere moisture—that is to say, the moisture in the air will turn the catalyst solid. Because of this, the lid of the catalyst container should be kept tightly closed, and replaced immediately after use. The Cold-Cure Silastomer tin should also be kept tightly closed after use. The life of these materials is limited.

Footnote. Every endeavour has been made to ensure that the information in this chapter is reliable, but neither the manufacturers, the publishers, nor the author can be responsible for the correctness of information or for any loss, injury or damage which may result from the use of the information.
It should be borne in mind that there may be uses or applications of the products mentioned in this chapter, which are protected by patents, and readers, in their own interests, should take the necessary steps to avoid infringement of such patents.

Chapter 11

Vinagels—P.V.C. Compounds for Modelling and Making Impressions

A new material has been produced, called **Vinagel,** a PVC based compound. It is excellent for modelling, and does not dry out on its own, but may be fired in a domestic oven to become hard and almost indestructible; when cured it has a very slight amount of flexibility. There is negligible shrinkage after curing, and for this reason the armatures may be left inside permanently without fear of cracking. This compound will not stick to plaster or polyester resin, whether in its raw form, or whether fired. Vinagel is supplied in several grades—putty and semi-liquid. Each grade has thixotropic properties, which means that the material will not sag or lose shape. Its non-sticking properties make it ideal for press moulding.

The Putty Compounds. These are made in several grades, of which two are suitable for modelling. They are VG.116 and VG.118. Both are easily worked with the hands, with tools, press moulded, embossed, etc. Vinagel will remain workable until cured by heat, and does not need to be covered in the same way as modelling clay.

The main characteristics of the Vinagels are that on kneading, they become softer and more easily workable. They will not show tool marks, may be handled without fear of distortion, and have the property of stiffening again when left for a short space of time. Vinagels are clean, non-smelling, and do not stick to the hands; any table or bench top can be used for working, since no water is required, and Vinagels leave no dirt, grit or mess. Different in its characteristics to clay, Vinagel is far more versatile than other man-made modelling materials, and has the added advantage that it may be fired for permanency. See plates 73, 74 and 75.

VG.116 results in a flexible object after curing, and VG.118 results in a much harder object, which is also more rigid. In their uncured form, both are similar in appearance, and much the same consistency.

The Semi-liquid Compounds. Vinagel 500 has the appearance of soft jelly, but becomes more fluid on stirring. It is applied with

73. Maquettes for a Memorial to the late President John F. Kennedy, 1964, by Mary Catterall. Standing figures fourteen inches in height. Modelled in Vinagel (photo: Kenneth Fensom).

a palette knife or putty knife. One of its main uses is in the field of flexible moulds. As any thickness can be spread over a metal master, moulds with any desired section can be built up; after curing, the moulds will be practically indestructible. The flexibility is sufficient, in many cases, to allow undercut castings to be withdrawn. It is not suitable for dip coatings.

74. Detail of the Negro Group from the Kennedy Memorial (plate 73), 1964, by Mary Catterall (photo: Kenneth Fenson).

Curing of Vinagels. Generally speaking, any thickness or block of any of the Vinagels, can be cured in an ordinary domestic oven, with settings that will vary between Regulo 2 and 3 (see page 34), for periods from twenty minutes upwards to four hours, according to the thickness. A good starting point is Regulo 2 for forty-five minutes with a test piece, to gauge under or overcure as described later. It will be appreciated that thin layers require only a little space of time to cure, whereas large lumps may possibly need three or even four hours. It is difficult to be specific as to curing times for all types of models, since some models will have parts which are thin, and other parts which are thick in section. In this respect, it will be found very helpful if large masses are avoided by forming hollow centres, and if wall thicknesses are limited to a maximum of $2\frac{1}{2}''$. As an example, a life-size portrait head could have a core of glass fibre wool which need not be removed afterwards for curing. In modelling solid articles such as animals, joints of meat, etc., an initial moll can be made of the subject and cured to obtain a solid core, which is then completely firm. Another coating of Vinagel may then be added for further modelling—such an addition will flux completely on to the moll and there will be no danger of parting. This process may be repeated several times, until the necessary bulk is obtained.

A little experience will be needed to ascertain the curing times of Vinagels. It is advisable to practice first of all with a few pieces of compound, before attempting to cure a model. The following notes will be found useful for curing.

Undercuring. This causes the material to crack after being removed from the oven, and it has the characteristic consistency of cheese. In this event, do not touch it, but put it back in the oven for a further period of curing.

Exact Curing. This causes a colour change in the material from its white opaque natural appearance to a more translucent appearance, with a colour change to light biscuit or straw. The terracotta Vinagel darkens in colour to resemble a true terracotta. In this form, when cool, the compound is flexible and practically indestructible. It may be handled without fear of damage.

75. A model from Vinagel 116. It is flexible, almost indestructible and permanent, once it has been cured in a domestic oven (photo: H. S. Atkinson)

Overcuring. Overcuring results in the colour becoming much darker, with a tendency to brittleness. Generally speaking, a large mass will cure better at a gentle heat (Regulo 2) (310°F) for a longer period of time, than at a higher heat for a shorter period. The reason is that the gap between undercure and overcure is much wider at a lower temperature.

If Vinagel is heated at too high a temperature for rapid curing, the outside of the model will be cured, but the inside will remain uncured. This may give rise to distortion. The best way of determining whether a model is cured sufficiently, is by gauging the colour of the material as described above. Vinagel shrinks slightly on curing, but the shrinkage is less than that of modelling clay, and to all intents and purposes can be ignored.

Some Notes on Handling

(*a*) If the material has been worked into a very thin layer, or has a heavy top on a lighter foot or base, it will crack, or have a tendency to do so, if left for more than twenty-four hours before curing. It is, however, ideal for modelling flowers, since it can be worked out to a paper thin section, and then bent into graceful curves without fear of cracking—such sections should be cured at once.

(*b*) When using VG.116 or VG.118 in a mould, remember that it will distort and lose shape if it is pulled from the mould without being left to set. If left for a few minutes, its thixotropic properties develop, and the case can be removed from the mould with very little distortion, which can easily be corrected. This thixotropic property means that models must be supported with an armature for the short period the compound needs for stiffening. Models should be supported on an armature in exactly the same way as in clay modelling; but, with Vinagels, the armature may be left in when curing.

(*c*) Vinagel may be thickened with ordinary starch, or thinned down with turpentine.

(*d*) Vinagels should be painted with PVC paints, or oilpaints.

(*e*) Should a slight alteration in the stance of a cured model be required this can be achieved by heating the model, and bending the part concerned; the part should be held in this position whilst the Vinagel is cooled under the cold water tap. This requires a little practice to gauge the exact amount of heat, etc.

(*f*) If a Vinamold mould is being made from a Vinagel master, first coat with Vinagel parting agent, and after 30 minutes, the master is ready for moulding.

(*g*) If Vinagel in its uncured state has been stored for any length of time, especially in cold conditions, it will be found to be in an easily crumbled condition. This does not mean that the material has deteriorated in any way. All that is necessary is to knead the material for a few moments in warm hands, after which it will regain its full plasticity.

Making Impressions and Press Moulding with Vinagel

Vinagel 118 is ideal for making fine impressions, and also

for taking fine impressions. With the latter, account should be taken of the thixotropic properties of the material (see page 114). The Department of Western Asiatic Antiquities in the British Museum use Vinagel 118 for making impressions from their large collection of cylinder seals and stamp seals, many of which are thousands of years old. Up to recently, impressions were taken with plaster of Paris, but now a modified form of Vinagel, pink in colour (Museum Terracotta Type 060) is used. The standard of seal reproduction has to be of a very high order indeed, and to achieve it, the following technique is used.

76. A finely engraved agate Persian cylinder seal of Darius I (521-485 B.C.), and an impression from it. The lower photograph shows a Vinagel 118 squeeze from it (Museum Terracotta 060 type) (photos: copyright British Museum)

Making Impressions. The working surface is a sheet of thick glass, kept scrupulously clean. Before use, it is dampened with a sponge to prevent the Vinagel from sticking too strongly to the glass surface. A piece of Vinagel 118 is kneaded in the hands until it is pliable; it is then flattened on a piece of hardboard by pressing it on to the surface of the glass until the thickness of the material is approximately $\frac{1}{4}$". It goes without saying that the hands must be kept very clean to prevent dirt marks from appearing on the surface of the prepared material. The surface is then dusted lightly with French chalk, and the cylinder seal or stamp is treated similarly; residues of chalk are removed with the aid of a camel-hair brush. In the case of a cylinder seal, it is pressed lightly on the surface and an even pressure maintained by means of a piece of soft flat wood, which is also used to roll the seal smoothly along the surface of the Vinagel. The seal is kept moving in a straight line by the finger and thumb of the other hand. An ordinary palette knife is used to cut out the desired section of the seal, and this section is covered at once and kept in a small box until placed in the oven for curing. If the impression is left uncovered for even a short period in a dust-laden atmosphere, then the perfection of the surface is impaired and it is rejected by the British Museum as being below standard. The impression is placed in an oven at 140°C for twenty-five minutes, and is allowed to cool naturally. After fifteen minutes, it is levered off with a palette knife, trimmed and mounted. (See plate 76).

It is of interest to note that this use of Vinagel provides considerably greater output for a given space of time when compared with previous techniques that were being used. The impression produced is very fine and almost indestructible. The Museum Terracotta type of Vinagel 118 (Type 060) is tinted pink, a colour carefully chosen after experiment as the most suitable for photography, and for legibility of the impression when exhibited under artificial light.

General Press Moulding. Providing there is no undercutting on the model, it is possible to make two-piece moulds with Vinagel. The original master is made in Vinagel and cured. The master is then painted with Vinagel parting agent, and allowed to dry. The complete master is half press moulded, and the edges of the mould treated with Vinagel parting agent. The other half is then press moulded, so that the two halves of the mould

fit perfectly. The complete thing, mould and master, is then cured in the oven. When cured, and cooled down, the mould is opened, the master removed, and more Vinagel squeezed into the mould to make a further replica. Instead of casting in Vinagel, one could also cast in plaster, cold-cast metals, etc.

An alternative way of making a Vinagel mould, which is particularly useful where there is slight undercutting, is to coat the master lightly with Vinagel parting agent, and after 30 minutes Vinagel 500 (the semi-liquid type) is then carefully brushed over the master, taking care to ensure that every crevice is filled. More Vinagel 500 is pasted over the surface until the desired thickness is built up, and a retaining wall can be positioned to prevent the material from flowing unduly. The thickness of the mould case should be between $\frac{1}{4}''$ to $\frac{3}{4}''$—anything thicker requires a longer time for cure and greater care in the curing, which might give rise to distortion problems.

After curing in a domestic oven, as already described earlier, it will be found that the Vinagel master can easily be separated from the new mould and further replicas made; the mould must be treated each time with Vinagel parting agent, before casting in Vinagel. No mould treatment is needed with plaster, etc.

The flexibility, both of the master and the mould, enable quite sharp undercuts to be incorporated. If, however, a plaster cast is being taken from the Vinagel mould, due allowance will have to be made for the inflexibility of the plaster, and therefore, a lesser degree of undercut is essential.

This method of casting is very simple, and needs no special equipment, or lengthy preparation. Just the Vinagel, the Vinagel parting agent, and an ordinary domestic oven are required.

Chapter 12

Sand Casting—Cavityless Casting

A very new process, which is currently regarded as a major break-through in sand casting technology, will be of great interest to sculptors who follow the more traditional methods of casting in metal, utilising the services of specialist founders. The new process is known as the full mould, foam vaporisation, or **Cavityless Casting Process.**

The original, whether it be sculpture, or a highly complex engineering pattern, is simply made in expanded polystyrene, which is then com-pletely enclosed in founders sand and boxed. When molten metal is poured, the expanded polystyrene is vaporised and the mould simul-taneously filled.

Development of Cavityless Casting. This system of casting was invented by H. F. Shroyer, who registered his patent in America in 1958. The early application of the process was largely for art castings. The technique was developed still further at the Massachusetts Insti-tute of Technology in the U.S.A. by Messrs. Duca, Fleming and Taylor, with the object of kindling interest among sculptors, foundrymen and architects in the art field.

The engineering aspects of full mould casting were developed further in 1962 by the Germans, who realised its enormous commercial possi-bilities. Since then, the process has become fully established in Germany and the United Kingdom, and more recently in the U.S.A., where it is now being widely adopted in a big way. In its present stage of develop-ment, the Cavityless Casting process is most suited for one off casting in metal, and just lately it is finding its largest application in ship building (among its uses is the replacement of castings which have become worn out or broken, and for which conventional patterns no longer exist), in making press tools for car body manufacturing in-dustry, and in general jobbing work in the foundry.

The process is still in the comparatively early stages of development, and much work has yet to be done to explore its full potential. However, its possible applications are becoming more numerous as time goes on.

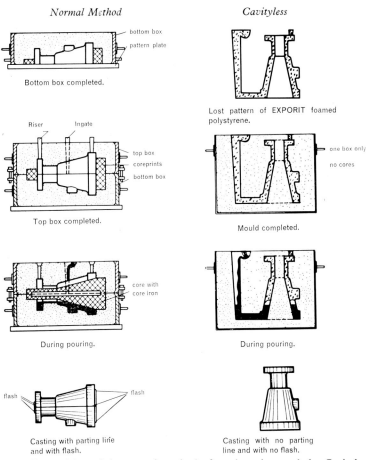

77. Comparision of the normal method of sand casting, and the Cavityless system. (drawings: courtesy Metalaids Ltd.).

Producing the Original Sculpture or Pattern in the Studio or Workshop. Expanded polystyrene is supplied in a foundry grade in standard blocks. The material may be cut to shape using conventional tools, or by means of hot wires. It is not necessary to carve a sculpture or form out of one single piece of expanded polystyrene, since pieces

may be glued together using a special impact adhesive. No armatures are required, whatever the size of the work. Figures 78 and 79 show an original made in expanded polystyrene (note that it has been made by gluing pieces together), and next to it is the finished cast in grey cast iron. Note the complexity of the shape, and how the surface texture has been reproduced on the cast. The surface of the expanded poly-styrene must be given a final finish, since any defect will be reproduced on the metal cast. Surface finishes may be produced by the normal means of sanding, rubbing down, and by the use of special combustible filler waxes and pastes; alternatively, textures may be incised on the surface.

Expanded polystyrene is remarkably easy to work and handle; it is very light, having a low density equivalent to about one twentieth that of wood. However, care should be exercised to avoid damaging when handling large, intricately worked pieces, especially when transporting them from studio to foundry (although damage is easily repaired).

At the Foundry. The expanded polystyrene sculpture or pattern is put into a box and is packed with foundry sand which does not require ramming, particularly facing sands bonded with cold setting resins, CO_2 or cement, in conjunction with natural bonded backing sand. The pattern is not withdrawn from the mould, and so the necessity for core boxes and core prints is largely eliminated. Compare the illustrations showing the difference between conventional and Cavityless sand casting. The addition of a runner and vent is, however, necessary and these are simply made in expanded polystyrene and glued to the sculp-ture or pattern before being packed with sand. Mould time is reduced to one fifth of that required for conventional sand casting methods. Castings may be made in iron, steel, bronze, aluminium, etc. weighing up to several tons. Larger works may, of course, be hollowed out, to reduce weight, and also to reduce the cost of metal used.

Dimensional accuracy of the casting is improved, since the dimensions of the pattern are reproduced exactly in the mould, and fettling of the finished cast is reduced drastically, because flash resulting from badly fitting cores and parting lines is eliminated.

Advantages to the Sculptor. The enormous advantages of Cavity-less casting to the sculptor are immediately apparent. Due to the almost complete elimination of core boxes and prints, the sculptor has great freedom from conventional limitations of sand casting. The range of shapes and forms which can be made is greatly widened. It is

78. A complex polystyrene pattern of which a cast-iron replica was made (see plate 79) (photo: Engineering Industries Journal).

79. The finished cast in grey cast-iron. Note the surface finish on the model and cast (photo: Engineering Industries Journal).

believed, with few exceptions that any shape which can be made in expanded polystyrene, can be cast by the Cavityless Casting process. Compare again illustrations 78 and 79: such a casting would be virtually impossible to make by the conventional method, and it would have been a job for fabrication (it is, of course, far easier to fabricate a complex shape in expanded polystyrene than in wood or metal!).

The other attractive advantage of Cavityless casting is the great reduction in costs, due to various factors. Firstly, the expanded polystyrene is cheap, and no re-casting into plaster is required. Secondly, the foundry costs are considerably reduced all along the line—no patterns, core boxes or core prints are necessary; this is a reduction in costs in itself, and the resulting time saving reduces costs even further; in addition, as already mentioned, fettling is very considerably reduced.

Conclusion. Perhaps the technique represents the biggest stride forward in hot metal casting since the invention of the lost wax process, whereby a pattern is made in wax, and subsequently removed by melting from the finished mould to create a mould cavity, used over 2000 years ago by the Babylonians and Egyptians. All in all, this new technique

80. The beginnings of an automobile press tool in polystyrene, being built up by a pattern maker (photo: Engineering Industries Journal).

is of much interest to sculptors, mainly because it frees them to such an extent from the fettering limitations on the shape of the art form and its complexity which up to now have bound them. Whilst the cost of casting is less than when carried out by conventional methods, it yet does not come anywhere near as low in cost as the Cold Cast Metal technique, but one cannot compare the two directly, for in essence, the applications of both techniques are so totally different. Both, however, have their place, and both have loosened, so to speak, the bonds which have limited the creative imagination from expression into final physical form.

Note. Cavityless Casting Process is patented (main British Patent is 850331). All materials are available in Britain from the Licence Holders who are able to grant sub-licences at very reasonable terms. The British Licence Holders are Metalaids Limited, Camp Hill Avenue, Worcester.

Chapter 13

Casting in Ciment Fondu

Just when concrete was first used for sculpture it is difficult to say, since it was an evolution from earlier techniques; there was, however, an outbreak of concrete garden ornaments in the early years of this century, objects that were crude both in form and method of production; and by the 1920s sculptors were using concrete in a limited way. Its full possibilities were not generally realised until some years after the last war, when it became quite suddenly popular in many parts of the world. This was in large measure due to sculptors from this country taking the technique abroad with them, and the reasons for its popularity are manifold.

In the first place, concrete is a cheap and very versatile material, and for some purposes will do a better job than any other. It can give a more faithful reproduction of clay modelling than plaster can, and it will take a variety of surface treatments. While it can, of course, be cast in a massive and heavy manner it is also possible to make remarkably light, hollow casts from it with the help of glass fibre. Such casts need be little heavier than those made with polyester resin, and concrete is the easier material to use. A life-size figure made of it can weigh much less than a hundredweight.

Concrete is a material that can be used also for direct modelling, but this is not a simple process; the method is discussed under the heading *Other uses of concrete*

The sculptor using concrete will, however, decide for himself whether to use it as a material in its own right or for imitating bronze or stone. It will do all these things.

An Outline of Method
Before proceeding to a detailed description of the various processes involved, the reader may find it helpful to know in brief outline the method used for casting in concrete. It is a simple one.

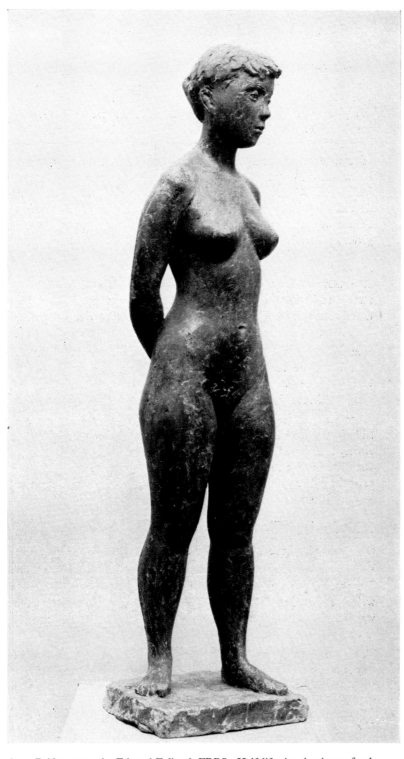

81. *Bridget*, 1953, by Edward Folkard, FRBS. Half-life size, in ciment fondu (photo: Edward Folkard).

Freshly-mixed concrete is placed in a suitably prepared mould, which may or may not have first been treated with a parting agent. When the concrete has hardened the mould is removed, as in plaster casting. If a piece of sculpture has had to be cast in several sections, these must first be joined together at the seams with concrete before the moulds are removed. More will be said in the appropriate place about the designing of moulds for ease in filling and assembly. This is the only part of the job which is likely to present difficulties if care and foresight have not been used. When the mould has been removed it may be necessary to do small repairs, and the surface of the concrete will be treated in the chosen way; and, if it is to be a piece of outdoor sculpture, it may be given a protective coating.

Moulds

It is assumed here that the reader has experience of working with plaster, and other mould materials if such are to be used instead, so no description will be given of making a mould, except where departures from normal practice are desirable.

A mould designed to be filled with plaster will usually do for concrete also, but there are some exceptions which will be explained later. Concrete is most commonly used in plaster moulds, but sometimes in **Vinamold** or rubber.

Since the concrete in the mould will take a day or two to set properly and since the mould itself must be kept thoroughly wet for at least twenty-four hours, there is considerable danger that the plaster will warp during this time. Consequently, if the sculpture is being cast in several sections of mould, the proper assembly of these sections will become impossible.

There are three ways of avoiding this trouble. Firstly, all smaller sections of the mould may be very thoroughly reinforced with stout irons, while larger sections may have strong wooden cradles built round them.

Since warping is usually due to the wet mould sagging under its own weight, a second method is to see that all salient points are supported by wooden blocks or props or other useful impedimenta at that moment to be found in the studio.

There is a third way that is sometimes more convenient. As soon as the clay is removed from the mould, temporary iron tie bars are fixed with scrim and plaster across its face. These must be placed so that they do not interfere with the filling of the sections of the mould, and since their

tie bar

82. Temporary iron tie-bar to stop mould warping.

presence would make it impossible to assemble the sections they must be removed immediately before the mould is put together again (pl. 82).

If, in place of plaster, **Vinamold** or a rubber mould is used, these precautions will perhaps be unnecessary because these moulds are waterproof, and though they usually have an outer case of plaster, this case may be kept dry, and the likelihood of its warping is much reduced. Plaster moulds frequently have a slight "feather" around their seams,

feather **brass**

mould **clay**

83. Feather left by brass shim.

which is the result of the brass foil having been pushed into the clay at a slight angle, causing an air gap on one side of the brass. This gap then fills with plaster. Visual inspection of the mould may reveal such plaster ridges, but it is best to run the fingers along the inside of all seams when the mould is open, so that if any ridges are felt they can easily be removed by light rubbing with a wooden tool. If they are not dealt with they will leave unsightly white lines showing up badly against the dark colour of the concrete. So if the mould is found to be faulty, put it right as far as possible before filling it: it is much easier to do this than to have to make alterations later to the cast itself.

127

Sometimes a lot of work can be saved by using moulds where the impression of the clay is taken in part by plaster and in part by **Vina-mold** or rubber. Areas of intricate form may be moulded in one of these pliable materials and the simpler areas in plaster (fig. 84).

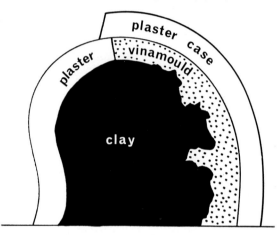

84. Combination of plaster and Vina-mold mould.

Parting Agents

The chief function of the parting agent is to prevent the concrete (or any other filling materials) from sticking to the mould as it hardens; thus it is first painted or sprayed on to the inner surface of the mould; but parting agents serve other purposes also—they may be employed to leave a film of colour on the cast, or to stop chemical reactions on the surface.

Thanks to a chemical reaction between them, a plaster mould may be filled with concrete without the use of a parting agent. The plaster does no harm to the concrete but the concrete rots the surface of the plaster, so that when the mould is chipped off there is left a film of softened plaster all over the cast; since this film has no strength the mould is automatically prevented from sticking to the concrete. The film is known technically as "bloom" and resembles the bloom on a grape.

Excessive bloom on a cast may be unsightly, however, so that parting agents are often used to reduce or even prevent it. Soft soap, as used in plaster casting, may somewhat reduce it. Wax polish is better, but it must be put on to a mould that has at least partially dried out, so that it has a chance to penetrate the surface of the plaster. The mould must of course be soaked again before being filled.

128

Materials

Of all the varieties available, Aluminous cement, e.g. **Ciment Fondu** or **Lightening,** is most commonly used. (The term **Fondu** will be used hereafter). It sets in about four hours, and then hardens very rapidly. It is relatively cheap. If used properly, it stands up to the weather excellently and gives an exact and accurate cast that is very strong. It is dark grey in colour.

A similar cement, sold under the name **Secar 250,** is white, and has all the advantages of Fondu, but it is more expensive. Either of them can have colouring materials added, or they may be mixed together to make intermediate greys.

These cements may be bought in one-hundredweight, half hundred-weight, and seven pound bags; Secar 250 is also available in fifty six pound resealable drums. Usually, when the work is finished, it will be found that some cement is left over, and this will keep for a long time if put into polythene bags to exclude all air. If it should go lumpy, how-ever, it must be regarded as suspect; it might still be usable if the lumps were removed with a sieve, but it would not harden as rapidly or as strongly as fresh cement. When in doubt, a small test mix should be made.

Sand is generally bought from a builders' merchant. It is sold loose, and by the bushel instead of weight, so a box or old cement bag should accompany you to the yard. A bushel equals approximately a hundred-weight. Since it is usually stored out in the open it will undoubtedly be wet, and it is quite extraordinary just how much water wet sand will hold. Even allowed to drain off, it may still hold too much water for your purpose, for when the cement is added the result can be a sloppy mix far too wet to use even without the addition of the water that you would otherwise have put in. All you can do, particularly in rainy weather, is to buy the sand well in advance and spread it out on a plastic sheet to dry; only in this way can the ultimate water content of the concrete be controlled. It is very important to get clean, washed sand free from clay and loam. Its cleanliness may be tested by stirring a tablespoonful of it into half-a-pint of water. The water should become only very slightly cloudy. It is, of course, perfectly possible to buy dirty sand and wash it yourself, but this can be very hard work.

The usual varieties available are known as Sharp sand, which has large particles; Soft sand, which is finer; and silver Sand, which is similar to Soft but lighter in colour. Silver sand is preferable with white cements, otherwise the mixture goes yellow.

Be careful always to use water that would be fit to drink. Dirty water could produce chemical action that would interfere with setting and hardening.

Mixing

The materials are always mixed in definite proportions by volume, since consistency must be maintained in all mixes used for any one job. The standard mix is:

cement	2 volumes
sand (dry)	6 volumes
water	1 volume

The cement should be lightly shaken down in the measure to ensure that it is evenly filled. For mixing a small amount of concrete all you need is a plastic bowl and a spoon, but for larger quantities a shallow wooden box and shovel are more convenient, while an old cocoa tin or cup makes an excellent measure, if kept clean and dry.

First measure out your sand, then add the cement, mixing very thoroughly. When making a large mix it is better to use the shovel rather than your hand, as otherwise a quantity of unmixed sand usually lurks on the bottom of the box. When these dry ingredients have been carefully blended, add the water and stir all well together, until the mix is uniform in colour and texture.

The Goo

The concrete is now ready for the mould, but in order to ensure a good surface, the mould needs first to be painted over with a cement slurry, commonly known as **Goo.** This is usually composed of cement to which enough water has been added to give a mix having the consistency of thin custard; it is used for portraits and small sculpture or for anything that is to be kept indoors. For outdoor sculpture it is safer to mix a "goo" of two volumes of fine sand to one volume of cement, with enough water to make the mixture just workable on a brush. This is more resistant to weather.

Always use freshly-mixed concrete and "goo". Mix enough for an hour's work at a time, but throw away any that begins to stiffen up before you can use it: on no account try to make it workable again by adding more water—it might still set, but would not be as strong as it should be.

Compacting the Mix

If you think of them as they would look under a powerful microscope,

85. A well compacted mix of ciment fondu, sand and gravel—note the absence of air pockets (photo: Lafarge Aluminous Cement Co. Ltd.).

grains of sand could be likened to tennis balls. No matter how carefully they are packed together there are bound to be air spaces between them. In the standard mix, however, these spaces are completely filled with cement if the mixture is properly compacted. Before being compacted, the mixture feels soft; a finger can easily be pushed into it, and if it is allowed to set in this state it will be weak and brittle, since it contains myriad tiny air pockets. The usual way of compacting the mixture is by a kind of light hammering, called tamping. For this the rounded handle of a screwdriver is a good tool. After being tamped the concrete should be firm to the touch, so that a finger does not easily leave an impression.

Curing

Too much water in the mixture, while it will certainly help to expel air and to make the sand particles settle down more closely together, will nevertheless result in a porous concrete, since the cement cannot absorb the excess moisture. Such concrete is weak and weathers badly. A mix should therefore be used which, to begin with, holds only the minimum amount of water to make it workable; but the moment it begins to harden it should be prevented from losing moisture, and once it is firm enough not to be dislodged in the mould it must be sprayed or covered with wet rags. Moulds that are small enough can at this stage be totally immersed in water. The vital point to remember is that the mixture must be kept wet until it is finally hard. Drying should not be confused with hardening. It the concrete dries too soon it will never harden properly and nothing can be done: no amount of water will help if given too late. The cement will remain weak or powdery.

If this should happen, the powdery part must be washed away with plenty of water and a stiff brush and refilled with freshly-mixed concrete. This process of keeping the concrete wet during the time that it is setting is known as **curing**. **Fondu** and **Secar** take twenty four hours to cure.

Aggregates

When the surface of a piece of work is going to be rubbed down to expose the aggregate, or be carved to a finish, a quantity of crushed stone, marble or brick is used in place of sand in the mixture. These materials, already sieved, can be bought from a mason's yard.

A good aggregate should contain particles of all sizes from say $\frac{3}{16}''$ down to $\frac{1}{64}''$ (which is about the size of a grain of sand), but should be free of dust, otherwise the mix will be weak when set. Crushed Polyphant makes an excellent aggregate that rubs down more easily than most.

No hard-and-fast rule can be given for the proportions of cement that must be mixed with different aggregates. Certainly it is better to have too much rather than too little, and there must obviously be enough cement to fill the air spaces between the granules. Two or three test mixes should be made up, using different proportions and tamping them down carefully on to a sheet of glass. When set and the glass removed,

the exposed surfaces should not be pitted, and when the sample is broken the mass should be seen to be free from air cavities.

When using unfamiliar aggregates, it would also be wise to make a test of the strength of the resulting concrete. This can be done with sufficient accuracy for our purpose by making a small block of concrete with the normal standard mix and another block with the chosen aggregate mix. Their strengths may be roughly compared by breaking them with a hammer or by using a mason's drill. The difference may be great.

Disposing of Waste

At this point a word of warning about the handling of waste concrete will not be out of place, for once concrete has set only a hammer and chisel can move it. So don't leave any in the mixing bowl or box or in the measures or on the floor and, important, don't wash any of the utensils or your hands at the sink: cement will merely be carried out of reach, to settle and set in the pipes. This can be expensive. Instead, fill a bucket and wash everything in this, and the next day, when the cement is no longer active, the water can be poured off and the solids safely disposed of. To protect the bottom of the bucket itself (or other container, which you may not wish to spoil), a useful trick is first to stir a handful of plaster into the water and leave it to settle on the bottom in a protective layer. The cement washings will then be more easily removed.

Casting Techniques

Lining the Mould

It is necessary to warn that some skill is involved in putting a mix into a mould properly.

The mould, if of plaster, must first be thoroughly soaked in water, otherwise it will act like blotting-paper and draw the water out of the mix; but any pools of water that form in the mould should be taken out with a sponge.

The "goo" is then applied with a brush. It should fill up all cavities and coat the remaining surface evenly about $\frac{1}{16}''$ thick.

Next, a small dollop of the mix is placed on the "goo" and spread outwards with the fingers, and on to the area so covered, some more mix is placed and again spread outwards. In this way a small wave of "goo"

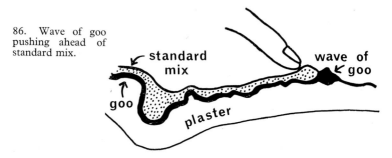

86. Wave of goo pushing ahead of standard mix.

is pushed out ahead of the mix, and the mix forces the "goo" out of the cavities in its path, and in this way air bubbles are avoided. (It is a good idea to practise this on a sheet of glass, as the result can be seen at once.) It does not matter that the "goo" itself is displaced: it is its function to get the mixture on to the mould without leaving air bubbles. It is better not to try to cover too large an area at a time; about two square feet will be enough to start with, if the sculpture is a large one. In this way the coating of "goo" can be quickly covered with the concrete mix, and this results in stronger work. When one such area has been covered, work on an adjoining area until the entire mould has been dealt with. There is no danger, when applied in this manner, of your materials not being freshly mixed. The mould should be coated, in the first instance, to a thickness of $\frac{1}{8}''$ all over, but where there are cavities or texture, the thickness should be increased, for reasons which will be explained in a moment, and the whole should have a smooth but undulating surface.

Glass Fibre Reinforcement

It has already been stated that sculpture cast in concrete can be exceedingly light in weight. By reinforcing the mix with glass fibre matting it is possible to make the end-product a very thin hollow shell. Glass fibre chopped strand mat is bought in sheets. It has great strength but is a springy and resilient material which "doesn't want to stay put" over sharp curves. It is for this reason that we try to eliminate the sharpness of the curves and to make the first coating of the mix both smooth and undulating.

134

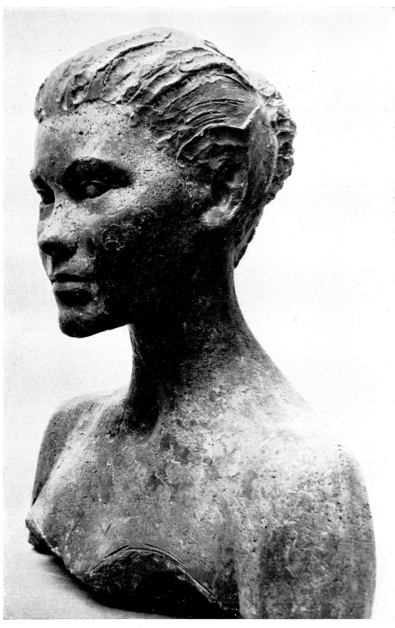

87. *Astrid*, by Edward Folkard, FRBS. Life-size portrait in ciment fondu (photo: Edward Folkard).

When this first coat has hardened (always remember to keep it moist while it is doing so), the surface should be painted over once more with a thin film of "goo". Pieces of glass fibre are then torn off the sheet, dipped in the "goo" and rubbed lightly between the palms to ensure their being completely impregnated. They are then pressed down firmly into the mould, each piece overlapping the other to give strength. In small moulds the pieces of matting might be about 2″ across; in larger moulds about six inches. In very "finicky" moulds, the mat may be split to half its thickness for greater ease in handling. One layer of glass fibre is usually enough for small work, of up to about twelve inches. Larger jobs will need two or three layers.

Since the "goo" contains excess water, the job can be made much stronger if the surface is sprinkled over at this stage with a mix containing only half the prescribed amount of water, which is then patted down on to the glass fibre and "goo". This adjusts the water content in the "goo" and results in a sandwich construction of sand and cement, glass fibre and cement, and again sand and cement (fig. 85).

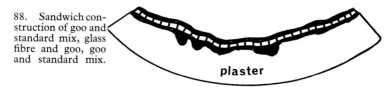

88. Sandwich con-struction of goo and standard mix, glass fibre and goo, goo and standard mix.

plaster

In cases where glass fibre is not being used to reinforce the mould, the first thin coating of mix, already described, will be added to uniformly and thoroughly tamped down. For a portrait head, a final thickness of about $\frac{1}{2}$″ all over will be sufficient, and for a life-size figure about $\frac{3}{4}$″, although in the latter case iron reinforcements will need to be added at a later stage.

Do not forget to make sure that each section of mould is well supported during filling, to prevent it warping.

Vertical Surfaces. It is quite simple to work up the sides of the mould as far as the vertical, by starting at the bottom and tamping the mix firmly into place as you go. However, an overhang must never be coated with mix from underneath. Wait till the following day, when the mix is thoroughly hard, turn the mould over and deal with the overhang from above, not forgetting, of course, to paint the set concrete first with **goo** (fig. 89)

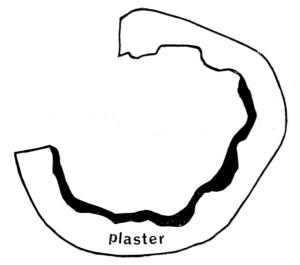

89. Working up side of mould leaving over-hang.

plaster

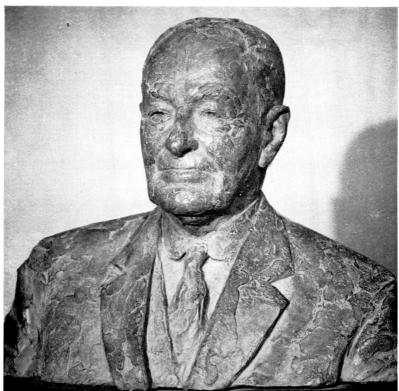

90. *C. R. Belling Esq.*, by Edward Folkard, FRBS. Life-size portrait in ciment fondu (photo: Edward Folkard).

Seams. As each section of the mould is filled, attention must be paid to the forming of the concrete edge round the seam. There are different ways of treating these edges, and the choice of treatment will be dictated by the method which will ultimately be used for joining the sections of the mould together.

Where the seam will be easily reached by hand from inside the mould during the assembly of the sections, the concrete is tapered up to the edge of the plaster and left with a rough surface. This leaves room for easy working during assembly (fig. 91).

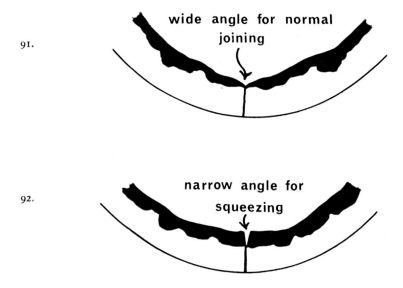

91.

wide angle for normal joining

92.

narrow angle for squeezing

Where the seam will not be easily reached, the concrete is built nearly, but not quite, up to plaster level (fig. 92).

As soon as a section of the mould has been filled, the edges of the plaster must be very thoroughly cleaned, for any concrete overlooked and allowed to set here will make it impossible for the sections to be assembled neatly and firmly together (fig. 93). This cleaning is best done with a dry, stiff brush, followed by a damp sponge, which should be rinsed frequently in water.

At this stage it is wise to check that the concrete is about $\frac{1}{16}''$ below the level of the plaster all round the seams. This gap leaves room for the concrete ultimately used in joining.

Where a seam follows switchback curves, concrete projecting above

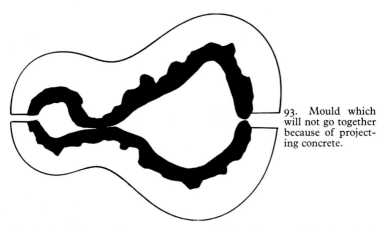

93. Mould which will not go together because of projecting concrete.

this level of about $\frac{1}{16}''$ may pass unnoticed and cause difficulty when set, so that a close join cannot be made. If this should be found to have happened, the projection can be carefully carved away with a stone chisel. (pl. 93).

Solid Casts. If small, simple moulds or reliefs are to be filled solid, the mix may be "vibrated" into place. As always, the mould is first anointed with goo, then a small amount of rather sloppy mix is thrown in and the mould is repeatedly tapped with a mallet. This shakes the mix into place and releases air bubbles which will be seen coming to the surface together with excess water, which can be taken off with a sponge. More mix is added, the tapping continued, and so the process is repeated until the mould is filled.

Alternatively, a vibro-massage machine may be used, the head being put right into the mix, which is added to a little at a time. This produces a very well compacted concrete, but it must be pointed out that the process cannot be used for hollow casts because vibrated concrete will not stay in place up the sides of a mould, always slipping down to the bottom.

Iron Reinforcement
The crushing strength of good concrete is enormous, something like four tons to the square inch; its tensile strength, on the other hand, is not nearly so great and it is therefore necessary to strengthen thin parts of some sculpture with iron rods embedded in the cast. The legs in a standing figure, for example, will need reinforcement if the figure is not to break away from the base at the ankles.

139

A number of iron rods of, say, $\frac{1}{4}''$ diameter are preferable as a rule to a smaller number of thicker ones. The irons must not be placed too near the surface. In engineering practice, they are normally kept $1\frac{1}{2}''$ deep in the concrete, but in sculpture this depth is not always feasible; nevertheless, if the rods are going to be less than $1''$ from the surface they will have to be treated with bitumastic or other waterproofing paint to minimise the danger of rusting. This, however, is not necessary for indoor sculpture.

In placing the irons you may have to compromise between conflicting advantages, strength on the one hand and weather-proofing on the other. Refer again to the ankles of a standing figure: if the irons are kept well in from the surface they become bunched together at the centre. This makes for weakness, since the more widely the irons are spaced the more strain they can take. If the ankles are, say, $3\frac{1}{2}'' \times 2\frac{1}{2}''$ in section, six to eight irons should be placed in each ankle about $\frac{1}{2}''$ from the surface, giving a spread of $2\frac{1}{2}'' \times 1\frac{1}{2}''$ (fig. 94). Some of these irons

94. Section through ankle of life-size figure showing best position for iron reinforcement.

should be continued to the top of the figure, and well across the base also.

If there is no danger from damp, however, as in the case of indoor work, slightly rusty iron can be a definite advantage, since concrete adheres more strongly to it than to smooth metal. Wire-netting is sometimes useful for reinforcing thin, flat shapes, but it has become almost obsolete now that glass fibre is available.

Assembly of the Lined Mould

The assembly of simple moulds presents no problem, but for complex moulds some forethought will be needed. No two moulds are the same but all are made on the same general lines, and difficulties once foreseen can be avoided.

Each section of mould should be placed temporarily in position and tied with string. As you do this, imagine yourself actually filling the seams

with concrete from the inside and you will at once see if any seams or parts of seams will be difficult to reach by hand, in which case the difficulties can perhaps be obviated by changing the order in which the pieces are assembled.

There are two ways of joining the sections together—by hand, and by squeezing.

Hand Joining

Where the seams are easily reached by hand, first fix the section in place with scrim and plaster, a wire tourniquet or string. Then from the inside work some "goo" into the seam with a brush, also brushing a band of "goo" an inch or so wide on each side of the seam. Back up on this with more concrete, and where extra strength is required use glass fibre and "goo" as well (fig. 95).

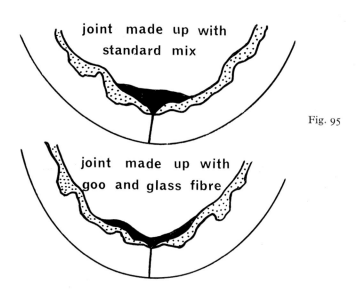

Fig. 95

Squeeze Joining

Where the seams cannot be reached by hand, they have to be **squeezed**. For this a thick "goo" is needed, made from five volumes of cement to two of water, which is ladled on to the edge of the concrete at the seams and raised into a rim all along each part to be joined. This rim must be built up well above the level of the plaster (fig. 96). It is important at this stage to have an excess of "goo" on the concrete. This will create a

gap between the two sections, which is now closed by hand pressure and tapping with a light mallet. As the gap closes, some of the "goo" will be squeezed out at the seam. This must now be wiped off, so that the seam becomes visible, and if it has not closed properly the tapping

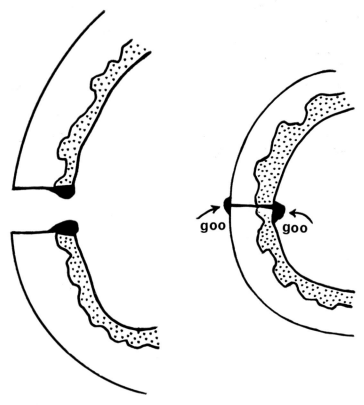

96. Seams loaded with goo ready for squeezing.

97. Finished squeezed joint.

should be continued. Neat and proper closure is extremely important. The section should now be fixed in place so that the joint will not be disturbed before it is cured (fig. 97).

Removing the Mould

A waste mould is chipped away as it would be from a plaster cast, and it will come away easily even if no parting agent has been used, leaving

the exposed concrete covered in bloom. The bloom should be scrubbed off with plenty of water; it is easily removed while still fresh but becomes increasingly difficult to shift if allowed to dry.

If the cast has a textured surface you should be prepared to spend some time in removing the specks of plaster that will be embedded in it. On a plaster cast many of these would not show and so would be ignored; but they show up strongly against the dark background colour of **Fondu**. The spike of a pair of compasses is a convenient tool.

Should your patience become exhausted while some specks still remain, you can stain them with grey-brown water colour. This will be absorbed by any remnants of plaster, but can be cleaned off the concrete surface with a damp cloth.

A "fin" or "flash" of concrete will probably be found to project from parts of the cast where the "goo" has penetrated and set between the plaster surfaces at the seams. It should be easy to snap this off with the

98. Fin projecting from seam after chipping out.

fingers, and any small part that remains may be rubbed down with carborundum or removed with a riffler (fig. 98).

If the cast has been made in a plastic mould, this can be removed in a matter of moments; but it should be remembered that **Vinamold** will leave a greasy deposit on the cast which is unpleasant to the touch and which makes an uncertain base for any subsequent colouring. The best way of removing this grease is by first washing down with white spirit on a brush and wiping with a clean rag, and then following this with an application of strong detergent solution in hot water.

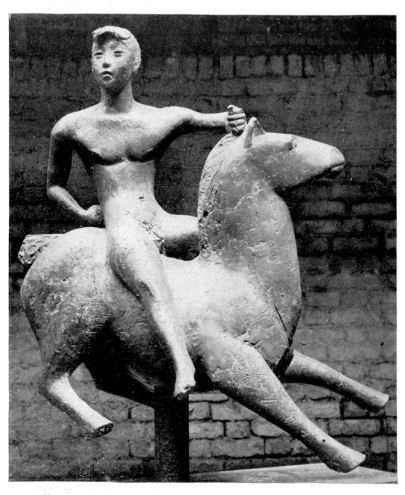

99. *Boy Rider*, by Edward Folkard, FRBS. In ciment fondu (photo: Edward Folkard).

Casting Routines

The summaries which follow are not intended to be self-explanatory but to act as reminders to the sculptor when casting.

Routine for simple moulds using glass fibre

1. Buy in materials and see that sand is dry.
2. When mould is ready, soak it.
3. Support mould with blocks or props to prevent warping.
4. Mix and apply "goo" to mould.
5. Put on first application of concrete mix.
6. Apply glass fibre impregnated with "goo" in one or more thicknesses, depending on the nature of the mould.
7. Pat in more mix, but this time made with only half the volume of water. This mix will absorb the excess water from the "goo".
8. Make up edges of seams, checking level of concrete all round.
9. Thoroughly clean plaster edges of seams.
10. Cover mould with wet cloths and sheet of Polythene, to cure for 24 hours.
11. When set, assemble sections of mould, making good the joints from the inside.
12. Again cure for 24 hours, then chip out.

Routine for complicated moulds

This routine is intended as a general guide. In any particular case there will almost certainly be items that can be ignored.

1. Buy in materials and spread out sand to dry.
2. Decide the position of the seams, bearing in mind the following:
 (a) mould sections should be easy to get off the clay
 (b) clay should be easily removable from the mould
 (c) armature must be removable
 (d) any piece of mould having an overhang will need to be filled in two sessions
 (e) squeezing sections together takes longer than making good from the inside, particularly if the sections are large
 (f) as in plaster casting, the sections should interlock, so that while being removable they will nevertheless go back properly into place

145

(g) the seams may show on the finished cast; therefore, other things being equal, they should be placed where they would be least unsightly

3. Apply any desired parting agent to mould.
4. Soak mould.
5. Support mould with blocks or props to stop warping.
6. Mix and apply "goo" over an area of conveniently workable size.
7. EITHER dust with dry mix (i.e., made with only half the volume of water) and pat in. This will absorb excess water from the "goo". Apply glass fibre and "goo", dust as above, and pat in. Apply further layers of glass fibre and "goo", if required. Dust and pat in.

 OR apply standard mix (or cement and aggregate), first in a thin layer, then to final thickness.
 Tamp thoroughly.
8. Make up edges of seams, carefully checking level of concrete all round.
9. Thoroughly clean plaster edges of seams.
10. Leave concrete to firm up, and as soon as it will take it without danger of shifting, spray it or wet it down.
11. Cover with wet rags and Polythene, or immerse in water for 24 hours.
12. Sections having overhangs will be continued when concrete has set, not forgetting to paint the set concrete with "goo" before adding to it.
13. Cut and bend irons and bed down in place.
14. When all concrete has set, make a trial run of assembling the sections in order to forestall any difficulties.
15. Assemble the sections in the predetermined order, making up the seams from the inside or squeezing sections into place.
16. Again cover with wet rags and Polythene sheeting for 24 hours to cure.
17. Finally, either chip off plaster mould and scrub down bloom, or remove **Vinamold** and de-grease cast.

Avoidance of Faults

Pitted Surfaces

The most common fault is a rough, pitted surface. This is often

the result of insufficiently thorough mixing, causing part of the surface to be too sandy, and the way to avoid this is obvious. However, this fault is more often due to bad handling of the mix as it is put into the mould, when small air bubbles get trapped on the surface. Once there, even a lot of tamping may fail to get rid of them, so the mix must always be put in with great care. Another possible source of the trouble may have been a plaster mould that was not properly soaked. Plaster being very porous, holds a great deal of air when dry; therefore if the mould is insufficiently soaked some of this air remains and then tends to come to the surface before the concrete has had a chance to set. This causes bubbles that show as pin-holes on the surface of the concrete.

Hair Cracks

Another common fault is hair-cracks on the surface. These are comparable to the crazing of the glaze on china. It may need a magnifying glass to see them, and since they do not penetrate to any depth the cast is not seriously weakened by them. Thus they are not important unless the cast is to go out-of-doors, in which case they afford an entry for frost and the cast may quickly deteriorate. The cause of these cracks is either too wet a mix initially or too thick a layer of "goo".

Bad Seams

Bad seams are the most unsightly fault of all. This is avoided firstly by seeing that the sections of mould go truly into place, and secondly by ensuring that the concrete is properly joined inside the mould wherever there is a seam.

Structural Cracks

Trouble can be caused by not measuring the proportions of each mix to maintain consistency, particularly in large moulds. If such a mould is filled with various strengths of mix, some too rich in cement, some in sand, and some too watery, etc., then the cast must be expected to crack. Such a crack may open up to as much as $\frac{1}{4}''$ and may not do so until a year or two after the cast has been made: so always measure the proportions of mix most carefully.

Since everyone can make mistakes, it is as well to know how to repair them.

Air bubbles on the mould produce pimples on the cast. Small ones can be knocked off with a stone chisel and a light tap with a hammer, or they can be rubbed down with carborundum. Larger pimples or bumps can be carved away, but this is a tedious and risky undertaking.

Any projections at the seams can be dealt with in these ways also.

Pitted surfaces or seams not properly filled can be made good by trowelling on small quantities of thick "goo" with a spatula; but it is important to wash the cast thoroughly beforehand, as any dirt already on it may cause the repair to fall away later.

The only difficulty with such repairs lies in curing the cement used. Since one is dealing here with such tiny amounts of material there is the danger that the repair will dry out before it can set—and subsequently fall away as dust.

If **Fondu** is mixed with **Portland** cement in the proportions of 1 to 3 the mixture sets in about half-an-hour, so the danger of drying out is avoided. This mixture may not be entirely reliable for outdoor work, but it has the advantage that it matches the colour of **Fondu** on which some bloom remains (which is normally the case) far better than a repair in pure **Fondu.**.

For work which is to be kept indoors many small repairs can be made using beeswax to which a trace of oil colour has been added. To do this, melt a little wax over a water bath; add turpentine and powder colour, and when cool model it into place with a spatula.

Colours and Surface Treatment

Fondu casts are usually scrubbed to remove bloom, allowed to dry and then wax polished. This gives a pleasant dark grey cast.

Secar and silver sand give a pale cast, usually of yellowish-white.

Secar and crushed marble give a white cast.

Secar and **Fondu** mixed together with sand give a series of greys.

Secar and crushed stone will give an effect very similar to the original stone.

To any of the above mixtures colouring matter may be added in the form of powder. These powders are supplied ready prepared for the job. Always make up a sample first, letting it set and dry to see what the effect will be. When using these powder colours it is wise to mix all the cement, sand and colour that will be required for the whole job before starting. This mixture is drawn upon as needed and then added to the appropriate amount of water. Only in this way can you be sure of getting a cast with a uniform colour throughout, but it is really important that the sand be bone-dry when the mixture is made up in bulk. However, if the cast is to be kept indoors it may be treated or coloured in a variety of ways on the surface only.

If the mould is thinly washed over with red clay slip before being filled, the clay becomes incorporated with the cast, giving it a reddish tinge. A more violent colour is produced by mixing red oxide of iron with the clay wash.

An effect somewhat resembling bronze is produced by vigorously rubbing the cast with a brass wire brush, such as those used for cleaning suede leather. As the concrete is somewhat abrasive it takes a trace of brass on its surface.

It is not difficult even to make the concrete look exactly like bronze. First have a good look at a real bronze cast and note the precise colour of the the brightest parts where the bronze is not patinated. These are always the projecting parts of the surface and their colour will be something between yellow ochre and raw umber. Mix powder colour with shellac and meths until you get this shade and then paint the entire cast with it. At this stage it will look hideous, but don't worry. Let the cast dry, look at the real bronze again and note the colour of the deepest recesses. This time use wax polish (such as Johnson's Traffic Wax) with the powder colours, but no shellac or meths. Brush this mixture all over the cast and well into any holes, and leave it to dry. Now take a cloth and wipe off the wax mixture from the high spots. If necessary dampen the cloth slightly with turpentine.

Casts can of course be painted in any colour, using matt or high gloss decorators' paints or, for exterior use, Polyurethane paints, but the effect is seldom pleasant. Outdoor sculpture can be bronzed by painting with Polyester resin and bronze powder, following the instructions given elsewhere in this book.

But there are people who feel that concrete should not seek to imitate any other material. Purists will not object, on these grounds, to the technique of rubbing down the surface of the cast to expose the aggregate, a technique which always involves a great deal of work. However,

on the simpler and more exposed surfaces of the cast an electric drill and sanding disc will be of great help, while small carborundum wheels and cones will be useful for awkward corners. A smog mask will stop the large quantities of dust from getting into mouth and nose. Casts that are going to be treated in this way should be made fairly thick and heavy.

If a soft aggregate such as crushed Polyphant (and no sand) is used in the mix, it may be practicable to rub down the job by hand, using carborundum blocks and water.

An interesting possibility is suggested by the fact that **Fondu** and **Secar** will stand high temperatures and therefore, provided there is no metal reinforcement present, can be fired like pottery. Grey **Fondu** mixed with grog in place of sand and fired to about 1000°C in an oxidising atmosphere comes out of the kiln a terracotta colour that is very pleasing. There is, however, a loss in strength on firing, so that this treatment is not recommended for articles which are to be permanently out-of-doors.

Outdoor Sculpture

No mere surface treatment will stand up to the weather except Polyester resin and bronze powder or Polyurethane paints and varnish, but the colours incorporated in the concrete should change very little with the years.

Fondu sculpture will usually become lighter in tone, in a year or two changing to a silvery grey. The acidic atmosphere, particularly of industrial areas, will have little effect on **Secar** and **Fondu** casts. Frost is the great enemy if it can gain a foothold, but this it cannot do if the cast is free from surface pitting and hair-cracks, for properly handled concrete is virtually waterproof. As a precaution, however, a coat of Polyurethane varnish is recommended. This dries with a glossy surface, but after being left for three days to harden, it may be rubbed down with steel wool to give a matt finish.

It is important that no pools of water collect on the sculpture. If there are parts of the cast that would hold water they must be provided with drainage holes large enough not to get blocked with dirt.

Changes of temperature are likely to cause condensation inside any

but a solid cast and therefore ventilation holes should be provided in a position where rain cannot enter.

Other Uses of Concrete

The use of concrete is not limited to casting. While it is not so easy to work as clay or as simple as direct plaster work, direct work in concrete can nevertheless be done.

A firm metal armature is built and on this the form is roughly established, using chicken wire covered with glass fibre and "goo". The concrete is now trowelled on, and continual light spraying with water will be necessary to cure it; but since there will be portions of the work in different stages of setting there is the danger that some concrete will get washed away. When building up on set concrete it must of course be painted with "goo" before any more is added.

Another method of starting is to use Polysterene foam as a basis, cut to shape, on which the concrete is built up.

Direct modelling in this way obviates moulding and casting; but it is much more difficult to manage than clay modelling, and the finished sculpture will be less strong, and also heavier, than if it had been cast.

Another way to make concrete shapes without first modelling is to make up the form required as a hollow box of hardboard or plywood, somewhat like the shuttering used in building. Plywood can be bent into curves and held by battens on the outside. With ingenuity a great variety of forms may be made. When the box is completed the inside should be painted with shellac and then waxed. While sculpture might possibly be made in this way, the method is primarily useful for making bases.

A kind of relief sculpture can be made by filling a large wooden tray with damp sand smoothed off to a level surface but not compacted too firmly. The surface may then be indented with a modelling tool or by pressing any object into it. Sea shells, keys and milk bottles have been used, and each leaves its impression. When the design is complete a wet mix of concrete is carefully run on to the surface without disturbing the sand. Once this has set, most of the sand will of course brush off, although some will remain to give the relief a sanded surface.

In place of the sand box, Polysterene foam may be used, which is obtainable in sheets of varying thicknesses. Since this foam melts at

any point where heat is applied to it, a design can be cut in it by using a heated metal tool or a soldering iron.

Large reliefs with a repeat pattern are generally made with a **Vinamold** or rubber mould of one section of the design. The required number of casts are made from it and fitted together. This method has been used for decorating a wall, and if part of the wall should be flat and part of it curved, the curved casts are easily made by securing the mould to a sheet of curved plywood.

In conclusion it may be said that concrete is very easy to use, after a little experience of its ways. Good concrete work depends on good materials well mixed, on good handling and compacting, and on good curing. Success need never depend on good luck.